The Campus History Series

UNIVERSITY OF

WASHINGTON

The Campus History Series

UNIVERSITY OF

WASHINGTON

ANTOINETTE WILLS AND JOHN D. BOLCER

ARCADIA
PUBLISHING

Copyright © 2014 by Antoinette Wills and John D. Bolcer
ISBN 978-1-4671-3182-7

Published by Arcadia Publishing
Charleston, South Carolina

Printed in the United States of America

Library of Congress Catalog Card Number: 2013954629

For all general information, please contact Arcadia Publishing:
Telephone 843-853-2070
Fax 843-853-0044
E-mail sales@arcadiapublishing.com
For customer service and orders:
Toll-Free 1-888-313-2665

Visit us on the Internet at www.arcadiapublishing.com

Dedicated to the faculty, staff, students, alumni, political and civic leaders, and friends who have built this university, and to those who preserve its history.

CONTENTS

ACKNOWLEDGMENTS

This book would not exist without the resources of the University of Washington Libraries Special Collections, which provided the majority of images, and the staff members whose expertise guided selection and preparation of materials, especially curator of visual materials Nicolette Bromberg and digital projects coordinator Kris Kinsey. Images from the Libraries Special Collections are identified as UWSC, followed by a negative number. The authors are grateful to the donors whose gifts to the University Archives Gift Fund helped support the cost of preparing the photographs. Thanks are also due to the university's Office of News and Information, and especially to Mary Levin, photographer and supervisor of University Photography, whose knowledge, skill, and patience in locating and preparing images were invaluable. Those images are identified as University Photography, followed by a negative or digital image number. Images also came from Seattle's Museum of History and Industry's collection of photographs from the *Seattle Post-Intelligencer* newspaper (Post-Intelligencer Collection) and from the *Seattle Times*.

For their encouragement and support in the initial planning for this book, special thanks are due to the staff of the University Book Store, and to Paul Rucker, executive director of the University of Washington Alumni Association (UWAA). Among people who have lived parts of the history contained in this volume, thanks are due to Emile Pitre, associate vice president in the Office of Minority Affairs and Diversity, who was a member of the Black Student Union when that group's activism helped to transform the university in the late 1960s, and Paul Zuchowski, associate director of the Husky Union Building (HUB), whose knowledge of the student union building and its history is unparalleled. Many colleagues helped identify and assemble the photographs in chapter seven. While they are too numerous to mention, their help was indispensable. Finally, every book needs a good editor, and that task was graciously done by Nancy Joseph, director of publications for the College of Arts and Sciences.

INTRODUCTION

The year was 1861. Washington was not yet a state; it was a sparsely settled region whose abundant natural resources attracted settlers. The pioneer founders of the University of Washington (UW) were focused on economic development, not higher education as it was then usually defined. They knew that the loggers, fishermen, farmers, and laborers in the region did not need to learn Latin and Greek, the classical subjects usually associated with a university. But they also knew that access to education of any kind would attract families to their still-tiny settlement, which they named Seattle after the chief of the local Duwamish Tribe.

In its early years, the university served as a primary school and high school, with a few college-age students. It opened and closed several times for lack of students and lack of funding. It did not grant its first bachelor's degree until 1876. By the time Washington achieved statehood in 1889, that period of uncertainty was over. Both the university and the city of Seattle were growing so much that the university needed a larger home than its original 10-acre campus in what is now downtown Seattle. In 1895, it moved to a spacious site in northeast Seattle, which continues to be its main campus.

This book was inspired by the University of Washington's 150th anniversary celebration. During that century and a half, the UW has grown to approximately 50,000 students on three campuses: Seattle, Tacoma, and Bothell. It is known as one of the world's leading research universities and an important resource in a regional economy that is increasingly focused on high technology, in fields from aerospace to software to life sciences. With hundreds of thousands of alumni, the university has grown beyond anything the pioneer founders could have imagined, yet the essential mission that motivated the founders remains the same: to provide access to education and expertise that contributes to a better life for people in the region and far beyond.

One way to measure the evolution of the university is to look at a brief chronology of the academic programs that reflect its growth. The schools and colleges awarding degrees are recognized as being established in the following order: the College of Arts and Sciences, 1861; the College of Education, 1878; the School of Pharmacy, 1894; the School of Law, 1899; the College of Engineering, 1901; the College of Forest Resources, 1907; the Graduate School, 1911; the School of Library and Information Science (now the Information School), 1911; the School of Business Administration (now the Foster School of Business), 1914; the College of Fisheries, 1919; the School of Nursing, 1945; the School of Medicine, 1946; the School of Dentistry, 1946; the College of Architecture and Urban Planning (now the College of Built Environments), 1957; the School of Social Work, 1958; the Graduate School of Public Affairs (now the Daniel J. Evans School of Public Affairs), 1962; the School of Public Health, 1970; the College of Ocean and Fishery Sciences, 1981; and the College of the Environment, 2009, which incorporates forestry, fisheries, and oceanography, as well as several other academic departments and programs.

The authors are intensely aware of how much of the history of the university could not be included in the brief overview contained in these pages. We hope that the photographs and captions will give readers insight into some of the highlights. Chapter one covers the early years, when the Territorial University—before statehood—was symbolized by the wooden building that housed it. Chapter two includes the move to a larger campus, the transformation of that campus when it became the site for Seattle's first world's fair in 1909, and the enduring legacies of that event. Chapter three focuses on the growth of the university during the presidency of Henry Suzzallo (1915–1926). Chapter four highlights some of the most challenging years: the Great Depression and World War II. Chapter five demonstrates a "coming of age," when the university added programs in the health sciences—the Schools of Medicine, Dentistry, and Nursing—that not only added a strong research component but also vastly expanded service to people in the region who never attended classes as students. Chapter six deals with an explosive era of growth and change, not only at the University of Washington but also in American society. Chapter seven begins with the expansion of the university from a single campus to three campuses, each with its own identity and culture, and ends with the celebration of the university's 150th anniversary.

In addition to serving students who are admitted to undergraduate, graduate, and professional programs on its three campuses, the UW has also provided educational opportunities to people in the community, especially working adults, for more than a century. In 1912, University Extension was formed, with the mission of making knowledge more accessible to citizens of the state. The guiding vision of Edwin Start, the first director, was to strengthen democracy by helping citizens and government agencies become better informed and more able to analyze and express ideas in civic discourse. Over the past century, the name University Extension was changed several times, and today it is best known as University of Washington Professional & Continuing Education (UWPCE). UWPCE serves approximately 49,000 people each year who want to complete an undergraduate degree or a professional master's degree, pursue a certificate program in fields ranging from computer programming to the creative arts, or take noncredit classes for personal or professional enrichment.

For those who want to learn more, we have included a brief bibliography. One can also discover what's new at the university's web page, www.washington.edu; keep learning at UWPCE, www.pce.uw.edu; and stay connected through the University of Washington Alumni Association, www.washington.edu/alumni. Founded in 1889, the alumni association is celebrating its 125th anniversary as this book goes to press.

One

THE TERRITORIAL UNIVERSITY

When the University of Washington was founded in 1861, Washington was a sparsely settled territory that would not become a state until 1889. Many people, including the territory's superintendent of public instruction, opposed creating a university in 1861 because there were not enough primary schools, to say nothing of high schools, that would prepare students for a university education. Henry Schmitz, the first alumnus (1915) to become president of the university (1952–1958), described the origins of the institution in these words: "The idea of a territorial University of Washington was conceived in a forest. The University was built in a forest from monies derived from the sale of forest land. For many years it served the educational needs of a people quite largely dependent on the forest for a livelihood."

Seattle had approximately 200 pioneer settlers, in addition to the native Duwamish Tribe inhabitants, when the university opened on November 4, 1861. The founders of the city and the university acted with what one described as "go-aheaditiveness." They believed that the university would contribute to the growth of their city and would be a benefit to people who were settling in a region blessed with an abundance of natural resources, including seemingly unlimited old-growth forests. The university's early years were tentative. It opened and closed several times for lack of funding or lack of students. It granted its first bachelor's degree in 1876, a full 15 years after it opened. By 1883, the Territorial University almost closed forever due to lack of funds. It was rescued by a gift of $4,000 from Henry Villard, whose Northern Pacific Railroad would soon reach the Puget Sound region. By the time Washington became a state, on November 11, 1889, the university and the city of Seattle had grown, just as the pioneer founders hoped. The university proved to be valuable to the region in its pioneering days, and that value continued to increase over time.

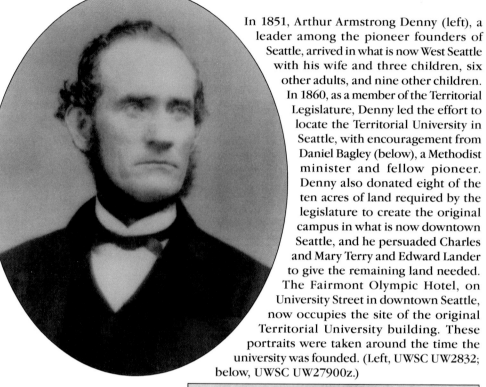

In 1851, Arthur Armstrong Denny (left), a leader among the pioneer founders of Seattle, arrived in what is now West Seattle with his wife and three children, six other adults, and nine other children. In 1860, as a member of the Territorial Legislature, Denny led the effort to locate the Territorial University in Seattle, with encouragement from Daniel Bagley (below), a Methodist minister and fellow pioneer. Denny also donated eight of the ten acres of land required by the legislature to create the original campus in what is now downtown Seattle, and he persuaded Charles and Mary Terry and Edward Lander to give the remaining land needed. The Fairmont Olympic Hotel, on University Street in downtown Seattle, now occupies the site of the original Territorial University building. These portraits were taken around the time the university was founded. (Left, UWSC UW2832; below, UWSC UW27900z.)

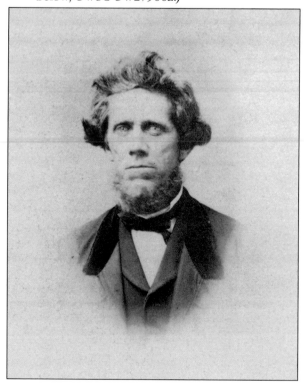

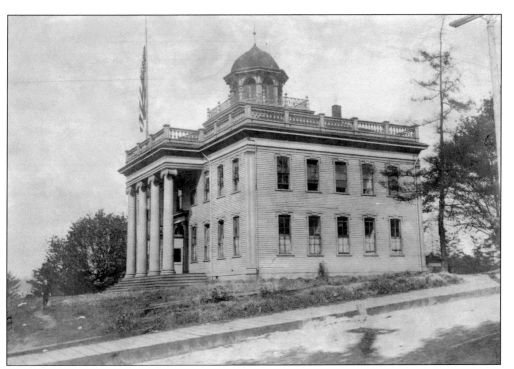

The photograph above of the Territorial University was taken the day instruction began: November 4, 1861. With only two college-age students among its 30 pupils, the university also served as a primary school. Asa Shinn Mercer, pictured at right in an undated portrait, was the university's sole faculty member and its first president. He was 22 years old; after graduating from Franklin College in Ohio, he had followed his brother Thomas Mercer to Seattle. Asa Mercer helped build the university in ways that his successors never had to: he worked as a laborer to construct the building that housed the Territorial University, and he traveled by canoe to logging camps around Puget Sound trying to recruit students. Mercer left the university after two years of struggling to enroll enough students to keep it open. (Above, UWSC UW3631; right, UWSC UW2209.)

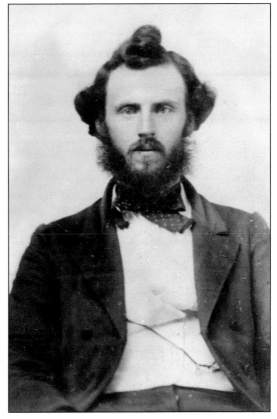

University of Washington Territory.

The University, situated at Seattle, W.T., having been reorganized and reopened, now affords every facility for parents to give their children, of both sexes, the benefits of a

FIRST-CLASS HIGH SCHOOL!

without sending them abroad.

The Scholastic Year is divided into Three Terms of Fourteen Weeks each.

Tuition, $6 to $10 per Term. Boarding, $50.

THE PRESIDENT HAS THE FOLLOWING ASSISTANTS:

F. H. WHITWORTH, a Graduate of the University of California, Professor of Ancient Languages and Mathematics.

MISS MAY W. THAYER, Teacher of Modern Languages, and

MRS. S. RUSSELL, Teacher of Music.

FOR FURTHER PARTICULARS ADDRESS

REV. GEO. F. WHITWORTH, A. M.

President of Territorial University, Seattle, W. T.

The Territorial University opened and closed several times in its first two decades. Efforts to keep it open included offering a "first-class high school" in addition to college-level classes. In the advertisement above from 1876, the reference to sending students "abroad" for high school meant sending them to more populated parts of the United States, not to foreign countries. "Boarding" was provided for men in a wood-frame boardinghouse. Women boarders lived at the President's House, shown below in an 1876 photograph, where parents could be assured that their daughters would be "watched over" by the president's wife. (Above, UWSC 35982; below, UWSC UW19609z.)

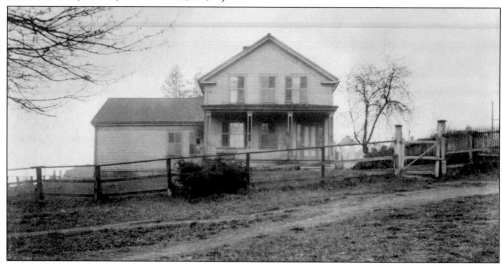

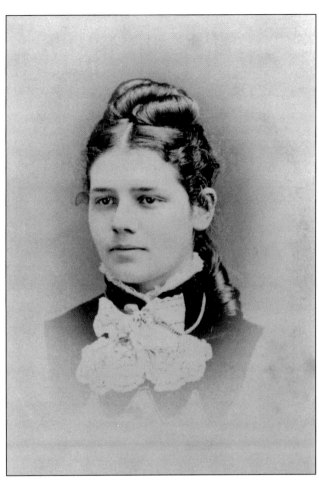

Clara McCarty of Puyallup, seen at right in an undated portrait, was the first person to receive a bachelor's degree from the Territorial University. The year was 1876, more than a decade after the university opened. She became a teacher, the usual occupation for an educated woman at the time. McCarty Hall, a student dormitory on the university's current Seattle campus, is named for her. The group portrait below of faculty and students from the early 1880s shows the range of ages of the student body, from very young to college-age. The Territorial University building housed classrooms for various grades, so not all of the students shown below were enrolled in university classes. (Right, UWSC UW3269; below, UWSC UW2227.)

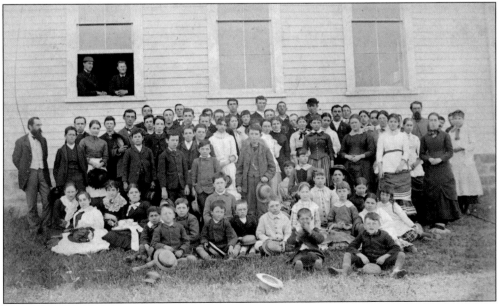

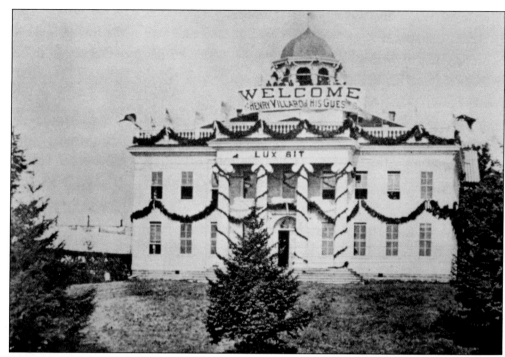

When the legislature failed to provide funding for the Territorial University in 1883, it was rescued by a gift of $4,000 from businessman Henry Villard, who believed that education was important to the future growth of the region. In September 1883, shortly after driving the ceremonial last spike of his transcontinental Northern Pacific Railroad, Villard arrived in Seattle. He was greeted with a parade that included an oxen logging team (below). A barbecue was held on the grounds of the Territorial University, which was decorated with a banner in his honor, seen above. The legislature appropriated $3,000 for the university in 1884, and it was never threatened with closure again. (Above, UWSC UW11985; below, UWSC A. Curtis 26438.)

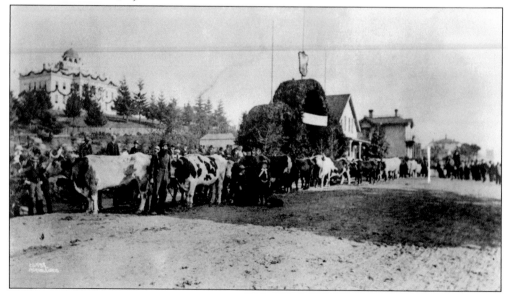

The faculty of the Territorial University in 1883 included Orson Bennett Johnson (far right), affectionately known as "Bug." As professor of natural science from 1882 to 1892, he built a scientific collection of Pacific Northwest flora and fauna, and taught and inspired others to do the same. Working with a group of eager amateur collectors, the Young Naturalists Society, he guided them in developing an extensive collection, organizing classes and lectures on natural history and creating a public museum on the university grounds. Among the students who joined the Young Naturalists were two men who would contribute greatly to the university's future: Edmond Meany and Trevor Kincaid. Professor Johnson's collection, and that of the Young Naturalists, gave rise to what is now the Burke Museum of Natural History and Culture on the UW Seattle campus. Johnson Hall on the Seattle campus is named for him. (UWSC UW28699.)

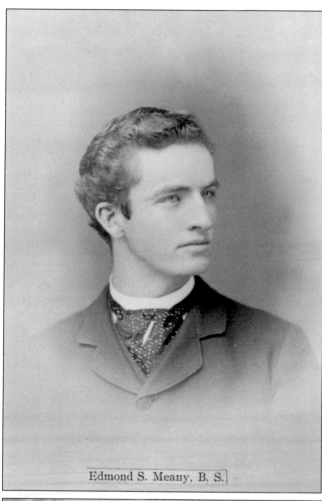

Edmond S. Meany, B. S.

Edmond Meany, one of the most important figures in the university's early history, is shown in the portrait at left, taken at the time of his graduation from the Territorial University in 1885. The photograph below shows him with fellow students in his Latin class in 1883—he is the tallest, in the center of the back row. After graduating, Meany devoted his considerable energy and enthusiasm to promoting the region and the university and to preserving its pioneer history. His roles included journalist, publicist, state legislator, and professor of history and forestry. He and his wife, Lizzie, also from the class of 1885, helped found the University of Washington Alumni Association (UWAA) in 1889. Edmond Meany became the third president of the UWAA, 1892–1893. (Left, UWSC UW889; below, UWSC UW35984.)

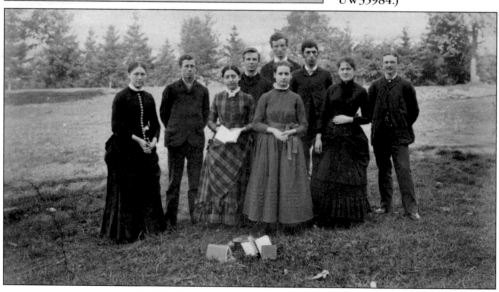

The Territorial University building was featured in this 1888 illustration, which graced the university's letterhead. A drawing of the original building was inset into a panoramic view showing the natural beauty of the region. The Olympic Mountains are in the distance, and ships approach Seattle on the deep waters of Elliott Bay. The university would soon leave its downtown location. By the 1888–1889 academic year, the number of college-age students at the Territorial University had increased, as shown below. The university's board of regents asked the legislature to authorize moving the university to alleviate overcrowding and to keep the students safe from the evils of city life. In their 1890 annual report, they called for "Ampler grounds . . . removed from the excitements and temptations incident to city life and its environments." (Above, UWSC UW3628; below, UWSC UW422.)

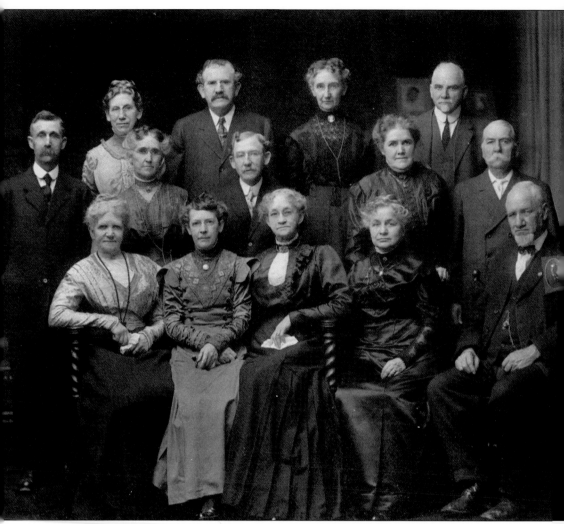

In celebration of the university's first 50 years, alumni from the first year of classes at the Territorial University gathered for a group portrait in 1911. Clarence Bagley, the son of Rev. Daniel Bagley, is standing at the far left in this group portrait. He had been one of two college-age students when classes began on November 4, 1861. Although he completed his college education elsewhere, he returned to Seattle and became a printer, publisher, and writer. A civic leader and founder of the Washington State Historical Society, he preserved the early history of the university and the region in two books: his *History of Seattle* and *History of King County*. The University of Washington Alumni Association, just 22 years old at the time of this photograph, has sponsored many 50-year class reunions, but none as historic as this one. (UWSC UW933.)

Two

NEW CAMPUS AND WORLD'S FAIR

In 1895, the University of Washington moved to a larger campus in northeast Seattle, which continues to be its main campus. The first building on the new campus, a sandstone structure resembling a French chateau, was a startling contrast to the wooden structure hastily built for the Territorial University in 1861. However, most of the new campus was still a "wooded wilderness," according to one of its early faculty members. Henry Landes, who arrived from Boston in 1895 to teach geology, took the streetcar from downtown Seattle to the new campus. He later recalled his first impressions in these words:

> A rambling trail led from the car-line, through the woods and among the big stumps, to Denny Hall. This was then called the Administration building, and was not yet finished, although occupied by teachers and students . . . When I reported for duty a few days after the term had opened, I was assigned a small room as yet unfurnished. With the help of willing students we rustled a few boards for seats, a big box which I used for a desk, improvised a blackboard, and started on the rocky road to some knowledge of geology.

The campus was transformed when it was chosen as the site for Seattle's first world's fair: the 1909 Alaska-Yukon-Pacific Exposition (AYPE). The Olmsted brothers of Massachusetts designed the site with a landscape plan that highlighted its natural beauty. They included a vista of Mount Rainier, whose glacier-covered peak can be seen on clear days, although it is more than 50 miles away. The overall goal of the event was to bring attention to Seattle's commercial potential as a hub for trade with Asia, as well as the gateway to Alaska's gold fields. A few permanent buildings built for the fair were intended to serve the growing university. After the fair ended, many of the temporary buildings were pressed into service, sometimes for decades, as classrooms, laboratories, and a museum.

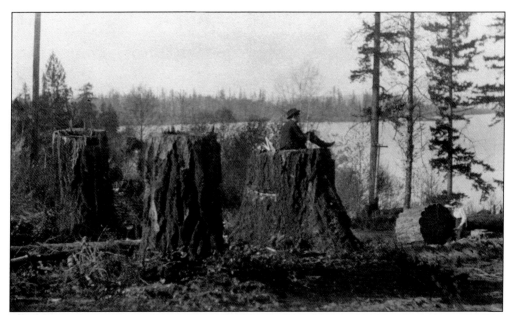

The "wooded wilderness" described by Henry Landes was filled with old-growth trees, whose size can be seen in this 1896 photograph. The new campus was between Lake Washington (visible in the background) and Lake Union. Both lakes influenced the university's future development, from the scenic views they provided, to the research they made possible, to the fame of the university's varsity crew teams. (UWSC UW18075.)

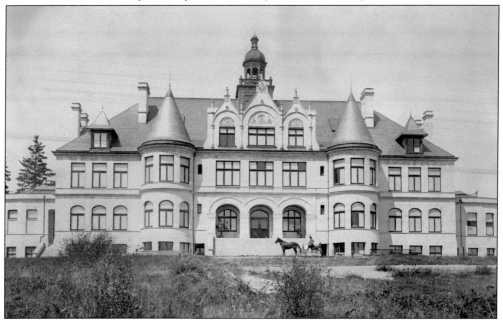

The first building erected on the new campus was originally called the Administration Building and later renamed Denny Hall, in honor of Arthur A. Denny. This elegant structure contained the entire university: classrooms, laboratories, the library, and offices for faculty, staff, and the president. Dormitories for men and women and a gymnasium/armory soon followed. (UWSC UW19769z.)

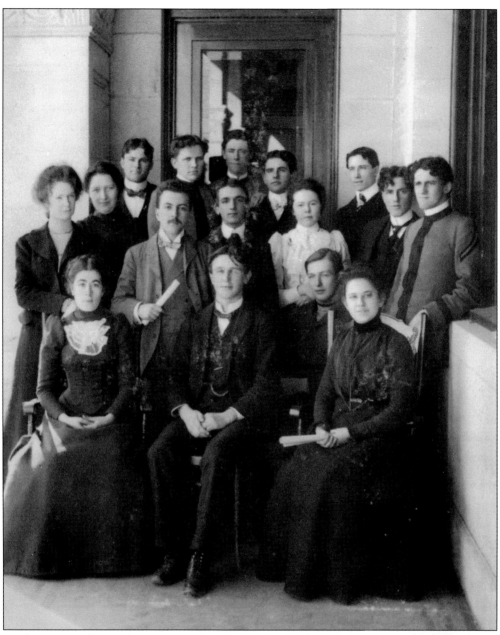

Students started several newspapers in the 1890s, including the weekly *Pacific Wave*, which was the most successful. This photograph shows *Pacific Wave* staff outside Denny Hall in 1899. The newspaper became the *Daily Pacific Wave* in 1908, and then the *University of Washington Daily* (now *The Daily*). It became part of a formal journalism course for which students could receive academic credit a decade after these students gathered for their portrait. Supported by student fees and advertising, *The Daily* has been the voice of the students for more than a century. Students in the photograph above would be amazed, and probably pleased, at the range of ways that *Daily* staffers now reach their audience. The print version is still distributed free on campus, but students can also access news and features through the Internet and communicate with *Daily* staff through Twitter. (UWSC UW6875.)

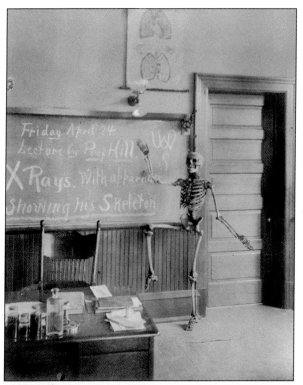

This skeleton is bringing attention to a lecture on x-rays in professor Charles Hill's 1896 biology classroom in the brand new Administration Building (now Denny Hall). Many people in the region hoped that the university would be able to provide medical training, but it would be another 50 years before a real medical school was established. (UWSC UW19754z.)

By 1903, the university's library collection had expanded enough to make this space in Denny Hall increasingly crowded. In its 1896 report to the legislature, the university's board of regents noted that approximately two-thirds of the university's library acquisitions had been received as gifts, as there were limited resources to purchase books. (UWSC A. Curtis 05393.)

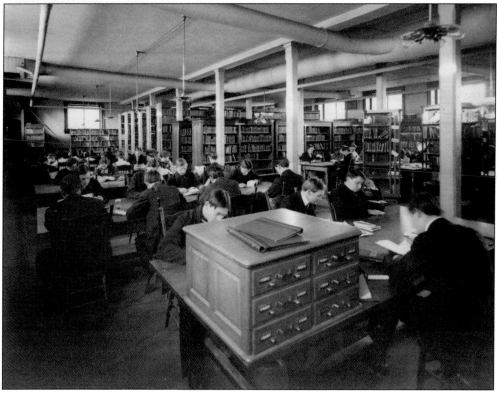

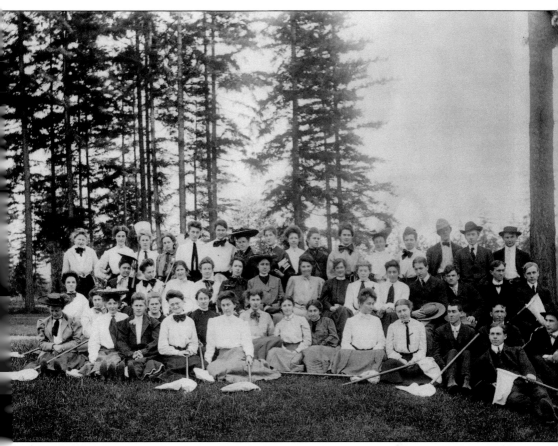

This 1905 photograph shows students in the popular zoology class taught by Trevor Kincaid (first row, fourth from right), who had been a student himself not very long before. As a faculty member, Kincaid's curiosity and enthusiasm were an inspiration to his students and a benefit to science and the regional economy. He identified many new species; 47 insects, plants, and animals are named for him. In 1904, Kincaid offered a summer session in marine studies in Washington's San Juan Islands, offering students an opportunity to learn from the remarkable diversity of marine life in the islands. That humble beginning led to the research and education facilities available today at the university's Friday Harbor Laboratories. Trevor Kincaid received his bachelor of science degree from the UW in 1899, and his master of science degree in 1901. He was hired to teach classes while he was still a student. (UWSC UW20329z.)

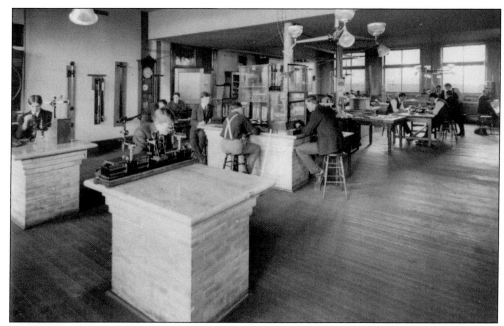

The physics laboratory in Denny Hall, photographed around 1903, shows how spacious and well equipped the university's new facilities were by that time. There was room for faculty to teach students through hands-on experience, a great improvement over the Territorial University building and the limited facilities that Henry Landes encountered on the new campus in 1895. (UWSC A. Curtis 5391.)

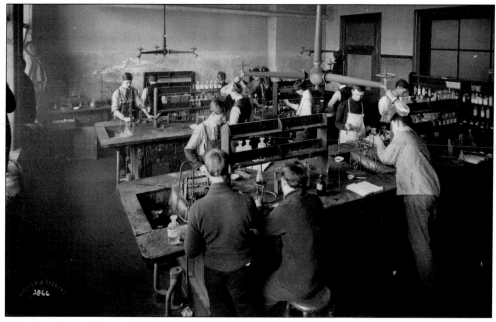

This chemistry laboratory, photographed in 1910, was probably in Science Hall (now called Parrington Hall), built in 1902. In 1896, there was one professor to teach chemistry. By 1910, there were six professors offering 20 chemistry courses, with an emphasis on applied fields like industrial chemistry, soil analysis, road oils and tars, and food analysis. (UWSC UW2359.)

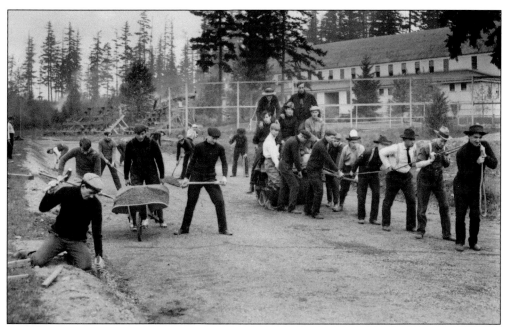

Campus Day was instituted in 1904 as a way to accomplish practical physical work on the new campus. Students like the ones seen here in 1907 worked together with faculty on projects like clearing brush, improving paths and trails, grading lawns, and building or repairing athletic fields. Campus Day became a cherished campus tradition that lasted three decades. (UWSC UW20269z.)

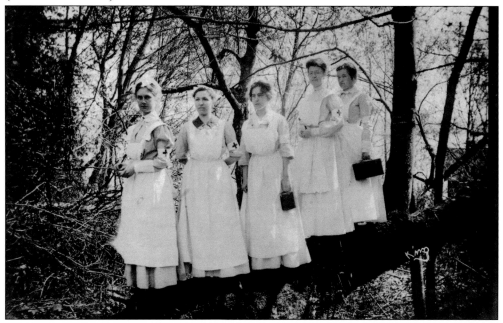

First aid was always available, and usually needed, on Campus Day. These nurses posed for a formal portrait in 1907 before tending to students who needed their help. While these nurses look like professionals, they were joined by many students, usually women, who supplied first aid over the years during Campus Day. (UWSC UW20262.)

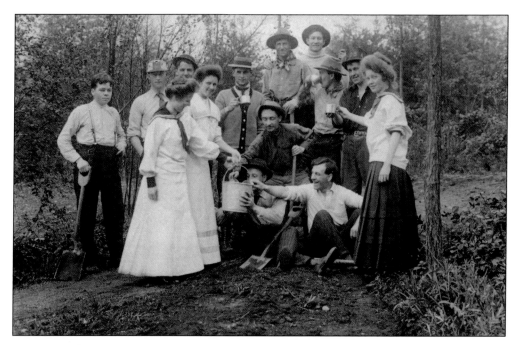

Women students served refreshments on Campus Day both out in the field and at a mid-day lunch. The photograph above was taken in 1908. A substantial meal was served at mid-day, with workers seated at long tables like those shown below in 1911. Male faculty members joined in organizing and supervising the day's work, and their wives and female faculty members helped with cooking and serving food or administering first aid. At the end of the day, faculty members and their spouses would usually retire to their homes while students had an informal dance in the evening. (Above, UWSC UW22715z; below, UWSC UW20424z.)

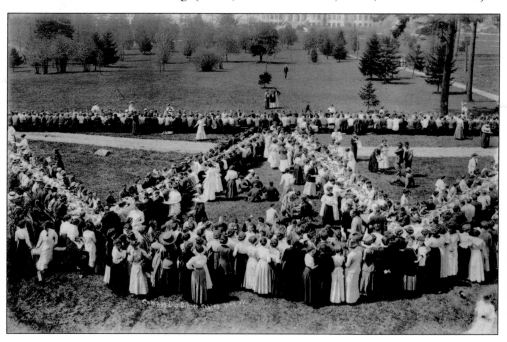

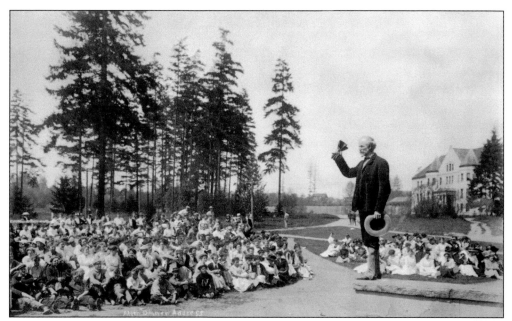

As a faculty member, Edmond Meany, class of 1885, had taken the lead in creating Campus Day in 1904. In this 1911 photograph, he is addressing students participating in the cleanup work. A historian by training and temperament, Meany became known as the "Keeper of Traditions" at the university. As with Campus Day, many of the traditions he "kept" were also created by him. (UWSC UW15725.)

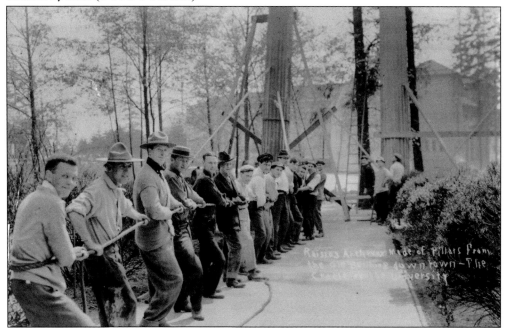

On Campus Day in 1911, students raised the wooden columns from the original Territorial University building on the path leading to Denny Hall. The original 1861 building had been torn down, but the wooden columns were saved. In 1921, the columns were moved to the Sylvan Theater, east of Rainier Vista, where they remain today. (UWSC UW22780.)

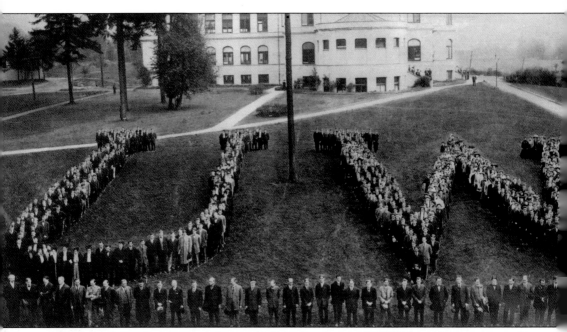

Students are lined up next to Denny Hall in the shape of "UW" for this commemorative photograph from 1909. Such photographs were a graduation ritual at the time. Students, faculty, and sometimes alumni would line up in an unusual formation for a group portrait that would appear in the *TYEE* student yearbook. The 1909 commencement was memorable because Seattle's first world's fair, the Alaska-Yukon-Pacific Exposition, was about to take place on the UW campus. The scale and significance of the world's fair was clear to the university's 2,156 students, who dedicated their yearbook to the Alaska-Yukon-Pacific Exposition, "which will erect its gleaming palaces on our campus, which will make our campus a spot on which will mingle all the races of the earth and a place where will be displayed all the wonders of science, art, commerce and invention." (UWSC UW21044z.)

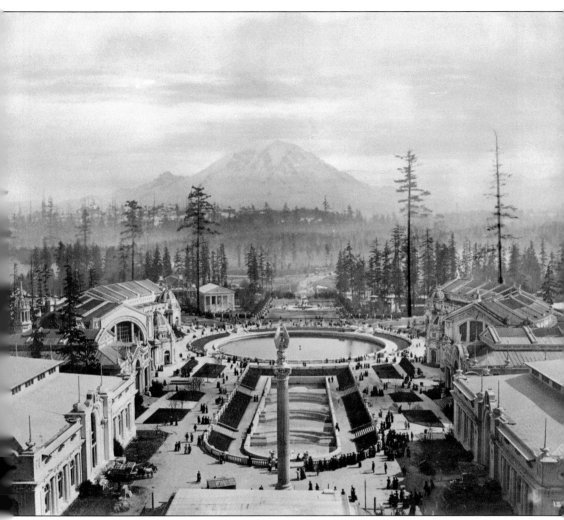

The Alaska-Yukon-Pacific Exposition was held on the UW campus from June 1 to October 16, 1909. It transformed the campus, with new buildings, many of which were temporary, and a landscape plan by the Olmsted brothers that shaped the university's future physical development. The university campus was chosen for the world's fair in part because it had abundant open space, and in part because it already had some of the infrastructure needed, including transportation by streetcar from downtown Seattle. This aerial view taken by the fair's official photographer, Frank Nowell, is a composite that makes Mount Rainier loom larger than it appears when seen from campus. Rainier Vista and the fair's Geyser Basin—the large pool at the center of this image—became enduring and beloved campus landmarks. Geyser Basin was later modified and became known as Frosh Pond, due to a long-gone custom in which upperclassmen tossed freshmen into the water in a ritual initiation. (UWSC Nowell x1040a.)

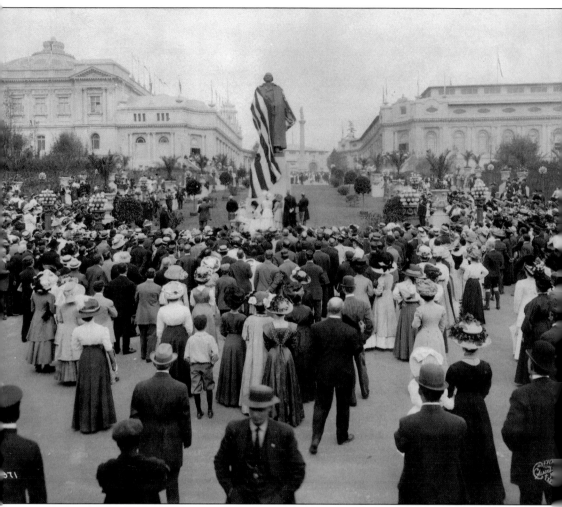

More than three million visitors attended the Alaska-Yukon-Pacific Exposition. On Flag Day, June 14, 1909, a heroic statue of George Washington was unveiled near the western entrance of the fair. It was commissioned specifically for the UW campus, paid for with gifts from the Rainier Chapter of the Daughters of the American Revolution (DAR), the state's schoolchildren, state funds, and other donors. Professor Edmond Meany, who had worked with the civic leaders who organized the fair as a representative of the university, was their liaison in commissioning the statue from American sculptor Lorado Taft of Chicago. The statue remains a prominent feature of the Seattle campus, still standing near the place it stood during the world's fair. Every year on President's Day, members of patriotic organizations like the DAR hold a ceremony on campus and lay a wreath at the base of the statue. (UWSC Nowell x1971.)

The Fine Arts Palace (above) was designed to be permanent, unlike most of the other buildings at the Alaska-Yukon-Pacific Exposition. After the fair, it became the home of chemistry laboratories, classrooms, and offices, and was known as Bagley Hall. Renamed Architecture Hall in 1950, it is now part of the College of Built Environments. The auditorium, below, was also designed to be permanent. In 1914, it was renamed Meany Hall in honor of professor Edmond Meany, the first time a campus building was named for a living person. The building was the venue for many campus and community events until it was damaged by an earthquake in 1965 and had to be demolished. The auditorium, classrooms, and performance space that replaced it are in a modern building that is also named Meany Hall. (Above, UWSC UW35868; below, UWSC UW30040z.)

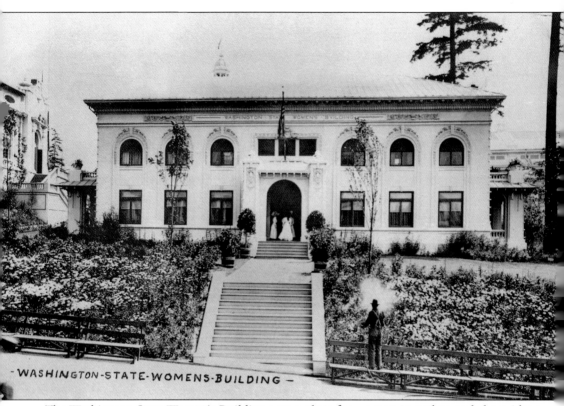

- WASHINGTON-STATE-WOMENS-BUILDING -

The Washington State Women's Building was a place for women to gather and share ideas during the Alaska-Yukon-Pacific Exposition. It also provided services for female fairgoers, including a nursery for children, and displayed women's work and achievements, including women's crafts. The fair attracted the National American Woman Suffrage Association, which held its convention in Seattle during the first week of July. Hundreds of suffragists attended from around the country. The publicity gained for the cause, and the efforts of countless women and men throughout the state, led Washington's all-male voters to approve voting rights for women in November 1910. The victory helped invigorate the cause nationally. Although designed to be temporary, the building is one of two surviving structures from the fair. Now named Imogen Cunningham Hall, in honor of the famous photographer who graduated from the UW in 1907, it is home to the Women's Center, which serves women and girls on campus and in the community with educational, service, and advocacy programs. (UWSC UW35869.)

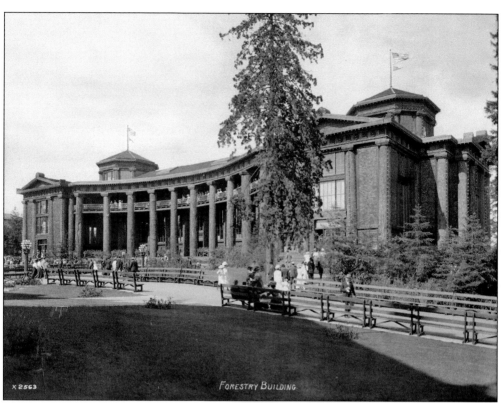

FORESTRY BUILDING

The Forestry Building at the Alaska-Yukon-Pacific Exposition was built of enormous logs from old-growth forests. It was sometimes described as "a Greek temple built by Paul Bunyan." The colonnade at the front entrance and the soaring interior spaces drew visitors' attention to the state's seemingly limitless forests. The fair's official photographer, Frank Nowell, posed the woman in the photograph at right at the bottom of a stairwell to illustrate the scale of the state's old-growth trees. After the fair, the building served as a forestry and botanical museum and also housed the natural history collections of the Washington State Museum (now the Burke Museum). Inevitably, insects and the elements weakened the structure, and it was eventually demolished. Currently, the student union building, known as the HUB (Husky Union Building), stands on the former site of the Forestry Building. (Above, UWSC Nowell x2563; right, UWSC Nowell x1148.)

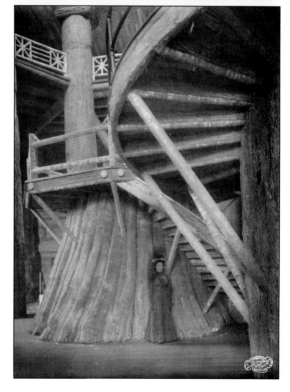

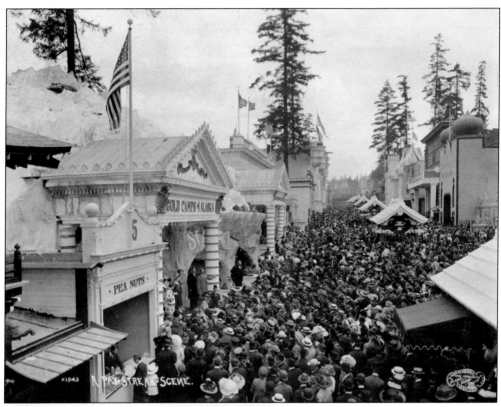

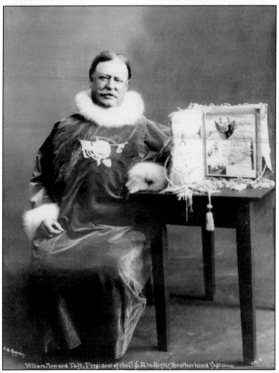

One of the most popular parts of the fair was the Pay Streak. It combined familiar places, like the Gold Camps of Alaska exhibit, shown here, with exotic elements like recreated temples from what was then called the Orient. Entertainment included a giant Ferris wheel and a hot-air balloon. Parades along the Pay Streak were frequent, as each day except Sunday was dedicated to a special theme. (UWSC Nowell x1543.)

Pres. William Howard Taft was among the famous visitors to the Alaska-Yukon-Pacific Exposition. During his day at the fair, he reviewed a parade and delivered two speeches. Taft was made an honorary member of the Arctic Brotherhood, a fraternal organization of men who had lived in the far north, and he posed for this unusual portrait wearing their official costume. (UWSC UW963.)

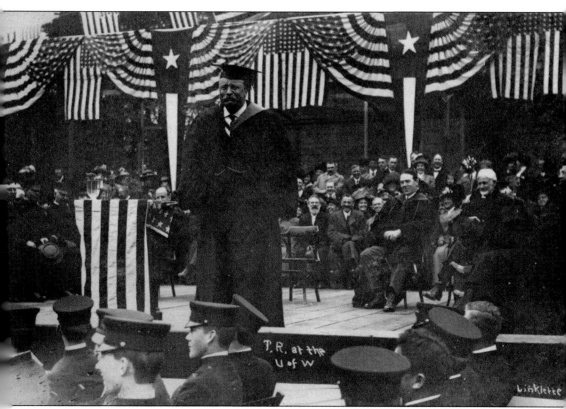

Former president Theodore Roosevelt visited Seattle on April 6, 1911. His activities included a parade downtown and a speech at the University of Washington. UW president Thomas Kane can be seen in this photograph, seated onstage in his academic robe. Roosevelt spoke in the outdoor amphitheater that had been built for the Alaska-Yukon-Pacific Exposition, taking advantage of a hillside on the northeast side of the campus. The amphitheater was replaced in 1967 by Padelford Hall, a modern building containing faculty and departmental offices. A multilevel parking garage was built into the slope of the hillside. Padelford Hall is named for professor Frederick Morgan Padelford, who joined the university's faculty in 1901 and later chaired the English Department. He became dean of the Graduate School in 1916, a position he held until his death in 1942. (UWSC UW22010z.)

Thomas Franklin Kane served as president of the university for 12 years, during which the student body grew from 600 students to 3,300, the faculty and curriculum expanded, and the university gained worldwide attention because of the Alaska-Yukon-Pacific Exposition. Originally hired as a professor of Latin and Greek, Kane had been promoted from dean of the Graduate School to president of the university in 1902. At the time, the regents were looking for stability after the political turbulence that had marked the previous administration. Although he presided over a period of tremendous progress, Kane's administration was not without controversy. In 1913, the board of regents informed him, "The University has grown beyond you." The regents wanted a man with greater vision and persuasive powers. They would soon find that man in the person of Dr. Henry Suzzallo. Kane Hall, home of the largest lecture rooms on the Seattle campus, is named for President Kane. (UWSC UW2117.)

Three

THE SUZZALLO YEARS

When Henry Suzzallo arrived as president in 1915, the board of regents had already approved a comprehensive plan for the university's future physical development. The world's fair had left a mixed legacy: a campus that included enduring elements, like Rainier Vista, and a few excellent fireproof buildings, but also many temporary structures that were still being used.

The university had existed for just over 50 years and had been on its new campus for only 20 years. Nevertheless, Suzzallo encouraged people to think in the long term and to believe that the UW could become one of the nation's leading universities. In his inaugural address, he said, "The true university is never a mere child of time: it is a foster-mother to things eternal." The entire address was reprinted in the alumni association's magazine, the *Washington Alumnus*.

A decisive administrator and dynamic public speaker, Suzzallo inspired people around the state to support the university. New buildings, better faculty, more students, and growing private support marked his presidency. The scope of his vision might be best summed up in the "President's Message" he wrote for the 1926 student yearbook: "The University of Washington is the farthest West of the American Universities . . . It lies on the seam of the garment of world civilization, where the oldest and the newest cultures meet. Its location charges it with a special intellectual responsibility to interpret the Orient and the Occident to each other. By the discharge of this simple duty it enlarges common understanding, the one solid ground for our hope of world cooperation and peace." By the time he wrote that message, the university had been through many trials, including America's entry into World War I in April 1917. The visionary campus plan adopted in 1915 had produced buildings that are still among UW's most admired. Despite the progress he made, in 1926 Suzzallo suffered the same fate as his predecessor, Thomas Kane: dismissal by the board of regents.

Henry Suzzallo became president on July 1, 1915. Educated at Stanford and Columbia Universities, he had served on the faculties of both when he was recruited to the University of Washington. He is shown at right in this photograph, taken at his inauguration on March 21, 1916. The other men are, from left to right, E.O. Holland, president of Washington State College (now Washington State University); Dr. Nicholas Murray Butler, president of Columbia University, who had recommended Suzzallo to lead the UW; and Gov. Ernest Lister, who came to rely on Suzzallo's administrative skills for tasks beyond the university. According to the student yearbook, on that afternoon Henry Suzzallo "dedicated his life to the tremendous service of making the University of Washington a vital force in democratic America" and received "an ovation such as had never before been witnessed on the Washington campus." (UWSC UW2114.)

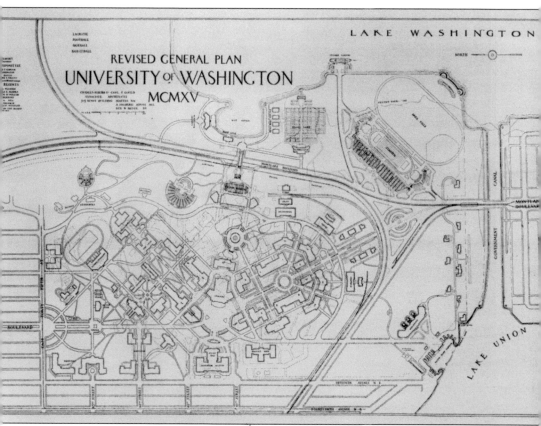

The 1915 Revised General Plan was approved by the board of regents as a comprehensive proposal for future development of the campus. The plan was produced by the architectural firm of Bebb & Gould, which would also design many of the buildings. Two main axes are visible: one pointing southeast for the Science Quadrangle (around the existing Geyser Basin and Rainier Vista, visible in the center right), and the other pointing northeast for the Liberal Arts Quadrangle, whose buildings were not yet designed or built. The two axes were joined at a large central square, in front of the future site of a library that was built in 1926 and was later named for Henry Suzzallo. Although it took decades to construct the major buildings projected in this plan, and many were never built, a comparison with a current map of the Seattle campus shows how important the 1915 plan was to the university's future. (UWSC UW6049.)

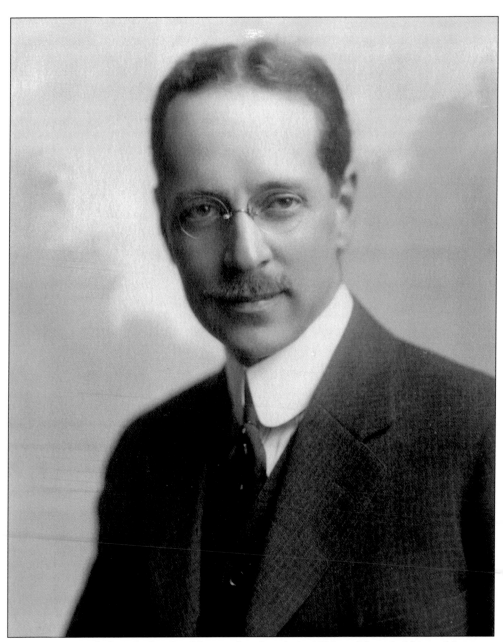

Born in New York City, Carl F. Gould moved to Seattle in 1908 and founded his architecture firm, Bebb & Gould, in 1914. Gould trained as an architect at Harvard and at the École des Beaux Arts in Paris, and that European influence was clear in his work. In addition to creating the 1915 campus plan for the UW, he designed 46 buildings or additions in the Collegiate Gothic style, including those on the Liberal Arts Quadrangle, the Suzzallo Library, and the Henry Art Gallery. Gould founded the university's Department of Architecture, which he chaired until 1926 when he left the faculty. In his private practice, he made an enduring impact on the region as the architect of many private residences and public buildings, including the Seattle Art Museum in Volunteer Park. Gould Hall, home of the College of Built Environments on the Seattle campus, is named for him. (UWSC UW21637.)

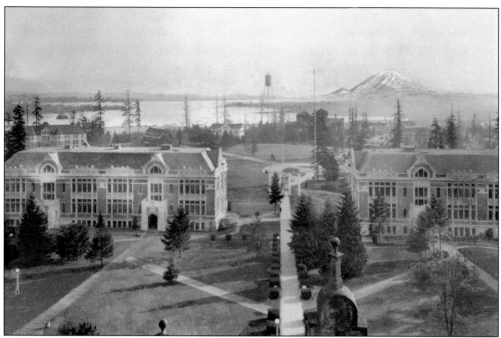

Construction of new buildings proceeded rapidly once the 1915 campus plan was in place. Financing for new buildings came from state funds, student tuition, and income from office buildings constructed on the original 10-acre campus in downtown Seattle. The 1919 photograph above, taken from the bell tower atop Denny Hall, shows Home Economics Hall (now Raitt Hall) on the left and Commerce Hall (now Savery Hall) on the right. Mount Rainier and Lake Washington are also visible, although few people had access to the bell tower to enjoy this view. The photograph below shows the same buildings in 1920, with the columns saved from the original Territorial University building, and Denny Hall in the background. (Above, UWSC UW6853; below, UWSC UW19053.)

Home Economics Hall was later named for Effie Raitt, who joined the UW faculty in 1912 as director of the Department of Home Economics after earning two degrees at Columbia University and serving as a dietitian in hospitals and sanitariums on the East Coast. At the time, home economics was a relatively new discipline that gave students, mostly women, "an opportunity to study the scientific problems of the home." Raitt and her colleagues prepared students for professional work as teachers and dietitians, clothing and textile designers, and other fields intended to improve family life and public health. Faculty in the department also offered classes to people in the community through the University Extension program, which was founded the same year that Raitt joined the faculty. Effie Raitt chaired the Department of Home Economics until her death in 1945. (UWSC UW36071.)

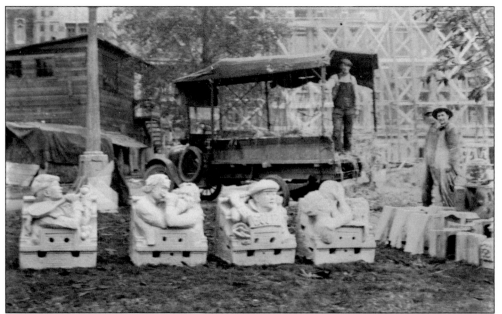

The buildings on the Liberal Arts Quadrangle are decorated with distinctive sculptures, although it is difficult to see their detail because they are located near the roofline. Raitt Hall, because it housed home economics, has sculptures of women in domestic activities. Savery Hall, whose two wings were originally named Commerce (1917) and Philosophy (1920), is decorated with sports figures, which the workers above are preparing to install. Miller Hall (1922), originally named Education Hall, has figures of students and teachers (right), as well as Asian and Native American sculptures. Alonzo Victor Lewis created the sculptures on Savery and Miller Halls shown here. Smith Hall (1939) has sculptures representing the state's natural resource industries as well as four figures on the northwest corner intended to represent Asia, the Americas, Europe, and Africa. The art and music buildings, constructed later, do not have this decorative element. (Above, UWSC UW19904z; right, UWSC UW35981.)

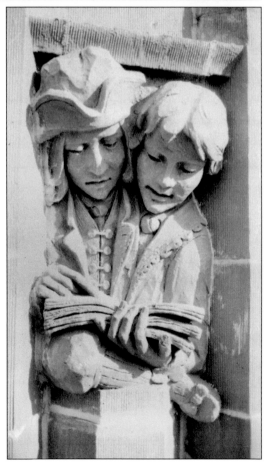

43

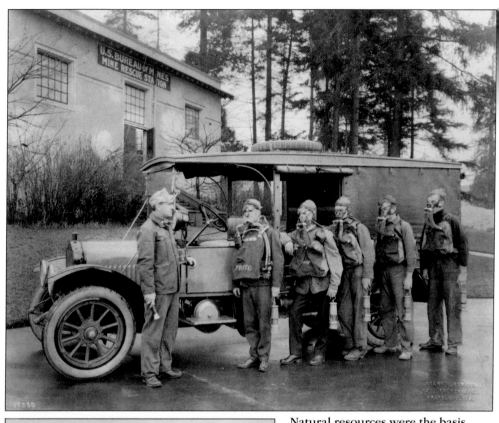

Natural resources were the basis of Washington's economy when these students from the College of Mines were photographed modeling mine-rescue safety equipment around 1915. As the state's economy changed to manufacturing, faculty teaching and research also evolved. The Department of Materials Science and Engineering, in the College of Engineering, traces its history to early programs in mining engineering. (UWSC UW20319z.)

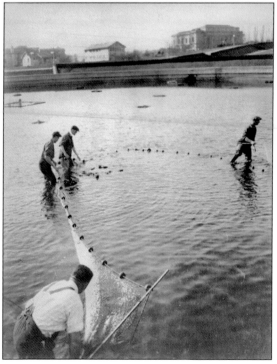

Geyser Basin was one of the enduring elements of the campus left from the 1909 world's fair. It has been put to unexpected uses, as in this 1921 photograph of College of Fisheries students practicing using a seine net. At the time, fish lived in what was by then known as Frosh Pond. (UWSC UW21846z.)

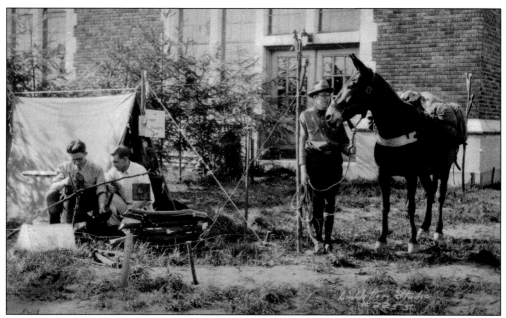

The forests of the Pacific Northwest have been an important part of the state's economy from the beginning. The forestry students shown above around 1925 are practicing skills they will need for their fieldwork. When not out in the field, forestry students had an elegant home for their studies. In 1923, Agnes Anderson made a gift of $250,000 for the construction of Alfred H. Anderson Hall to house the College of Forestry. The gift honored her late husband, who had an important role in shaping the state's timber industry. Completed in 1925, Anderson Hall (below) was the first building on the current Seattle campus funded with a gift. The College of Forest Resources (now the School of Environmental and Forest Sciences) became part of the newly created College of the Environment on July 1, 2009. (Above, UWSC UW19513; below, UWSC UW28732z.)

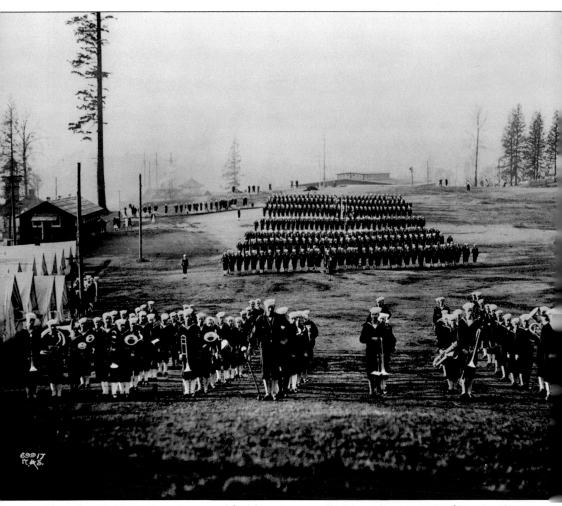

More than 1,500 UW students and faculty were enrolled in military service from April 1917, when America entered World War I, until the war ended with an armistice on November 11, 1918. A total of 58 alumni, students, and faculty members died in the war. The University of Washington was unique among institutions on the West Coast in offering training for three military branches: Army, Navy, and Marines. The largest encampment, which took over the golf course on the south campus, was dedicated to naval training. A tent city arose to house more than 700 Navy men, including some who had recently been students and some who were already in the Navy. The space reverted to a golf course after the 1918 armistice. It is now the site of the Warren G. Magnuson Health Sciences Center and the UW Medical Center. (UWSC UW36074.)

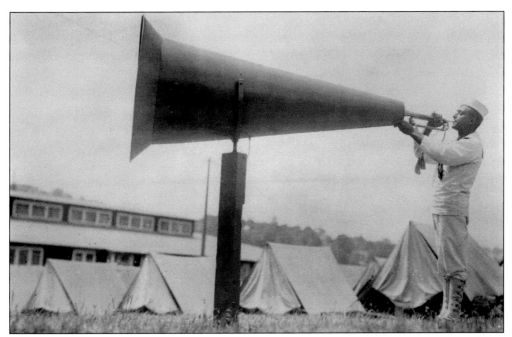

Navy men in the tent city were awakened each day by the sound of a trumpet amplified through a huge megaphone, as shown above. Other technologies employed in military training were more advanced. The university offered radio training for the Signal Corps, training in aviation and aeronautical engineering, and training in marine and civil engineering. Various departments of the university contributed expertise, from food safety to mining methods to military French. The University Extension Service—a new name for the educational outreach program founded in 1912—offered correspondence courses to soldiers far from campus. Life in the tent city could be primitive, as shown below, but recruits seemed to approach it with youthful energy and camaraderie. (Above, UWSC UW36073; below, UWSC UW36075.)

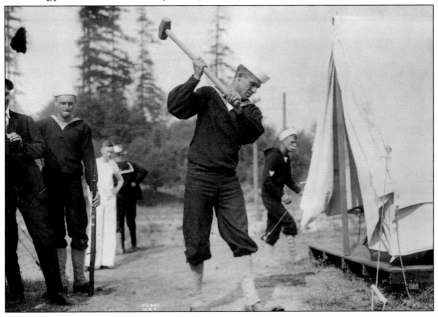

Lewis and Clark Halls, originally built as men's and women's dormitories in 1899, became hospitals during World War I. During the fall quarter in 1918, as the war in Europe ended, a worldwide influenza epidemic broke out. It was often fatal to young people, and many students were treated in the campus hospitals. Fall quarter began October 2, but classes were suspended from October 5 through November 12 because of influenza. By December, the epidemic had subsided, the war was over, most of the military units had disbanded, and the faculty decided to grant full credit for coursework during the quarter. As campus life returned to normal, Clark Hall (above) became the women's dormitory again. Below, residents of Clark Hall pose on its front lawn in 1921. (Above, UWSC UW19737z; below, UWSC UW16998.)

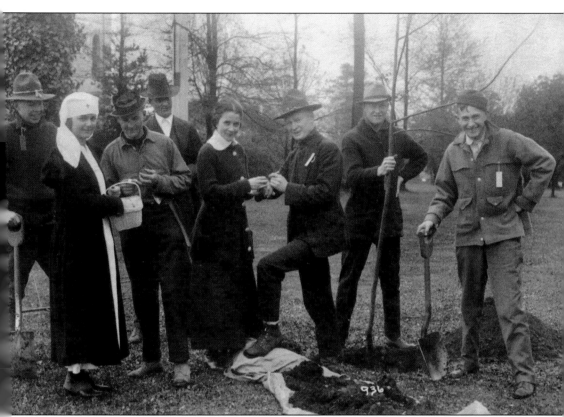

This photograph was taken on Armistice Day in 1920, when students, some of them military veterans, planted London Plane (sycamore) trees along the new Seventeenth Avenue Northeast entrance to campus. The trees honored the alumni, students, and faculty killed in the war. Stone pylons with plaques listing the names of those who died were added at that campus entrance in 1928. Although World War I was thought to be "the war to end all wars," lasting peace was elusive. The flagpole at the southern end of that campus road, Memorial Way, lists the names of students, faculty, and alumni who died in World War II. A monument honoring University of Washington alumni awarded the Congressional Medal of Honor was added north of the flagpole in 2009. Memorial Way is the most dramatic campus entrance because the trees planted in 1920 now form a cathedral-like canopy over the broad boulevard. (UWSC UW21955z.)

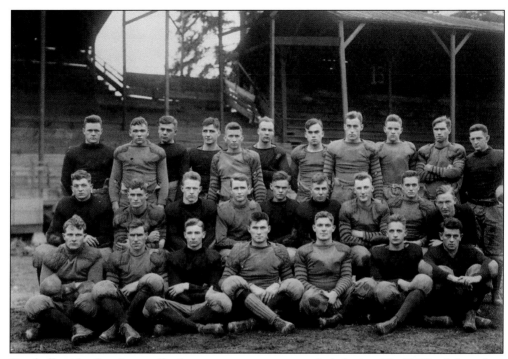

Football and other intercollegiate sports were suspended during World War I, but they resumed when peace returned. The photograph above shows the 1919 football team on Denny Field, the main venue for athletic competitions. Denny Field proved too small when thousands of fans had to be turned away from the 1919 Thanksgiving game. Athletics were the responsibility of student government at the time, and a new stadium was suggested by students. The idea proved popular, and a joint effort by students, the university administration, the alumni association, and citizens statewide gave the football team a new place to play within a year. The photograph below shows students cleaning Denny Field on Campus Day in 1920. It continued to be used for other sports, and currently includes grass fields, tennis courts, and a basketball court. (Above, UWSC UW35983; below, UWSC UW22707z.)

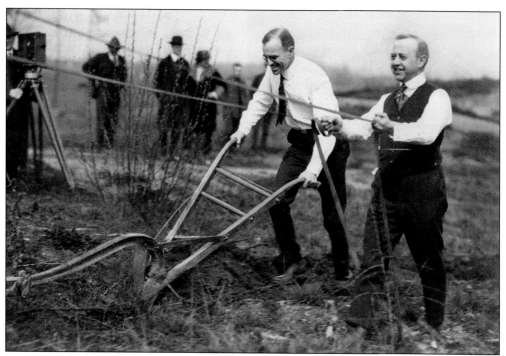

Building the stadium was a milestone event for the region and the university. Above, Seattle mayor Hugh M. Caldwell and UW president Henry Suzzallo help launch construction during the ground-breaking ceremony on April 16, 1920. The mayor handles the plow, while the president holds the reins of the plow mule. The first game in the new stadium took place on November 27, 1920, with Dartmouth beating Washington 28-7. The photograph below shows a halftime ceremony on the field during that game. The stadium was extremely modest compared to its subsequent expansions. An extensive renovation, including changes to the original 1920 bowl, was completed in 2013. (Above, UWSC UW23025; below, UWSC UW23027.)

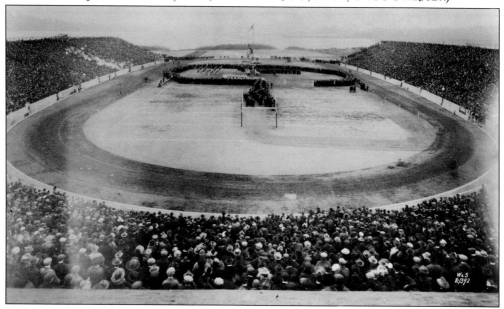

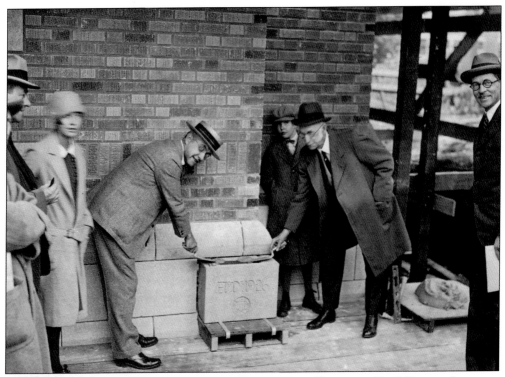

The second building on the Seattle campus funded with a gift was the Henry Art Gallery, the first public art museum in the state. In the 1926 photograph above, Henry Suzzallo (left) and Horace C. Henry (right) set the ceremonial cornerstone. Horace Henry, who made his fortune in real estate and railroads, wanted to give the public access to his collection of French and American paintings. When he sought a permanent home for his collection, his friendship with Henry Suzzallo led him to donate the collection, and a building to house it, to the UW. In 1997, the Henry Art Gallery expanded to four times its original size, again funded with private gifts. The photograph at left shows the original entrance to the museum, with the 1909 statue of George Washington reflected in its doorway. (Above, UWSC UW3632; left, UWSC UW6700.)

The greatest example of Carl Gould's Collegiate Gothic architecture and Henry Suzzallo's ambitious vision for the university was the main library, which Suzzallo called "the soul of the University." The 1927 photograph at right shows the first wing of the library, completed in 1926, with Philosophy Hall (now Savery Hall) on the Liberal Arts Quadrangle in the background. Three additions have been built to accommodate the growth of UW since this original wing was completed. None, however, is as ambitious as the 1926 wing, with its spectacular reading room (seen below around 1930). The architects designed the oak tables and chairs in that room, as well as carved oak friezes depicting native Washington plants and the elaborate iron-and-glass hanging lamps. A 300-foot-high carillon tower was included in the original plan for the library but never built. (Right, UWSC UW18756; below, UWSC UW20056z.)

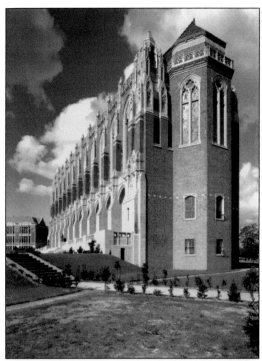

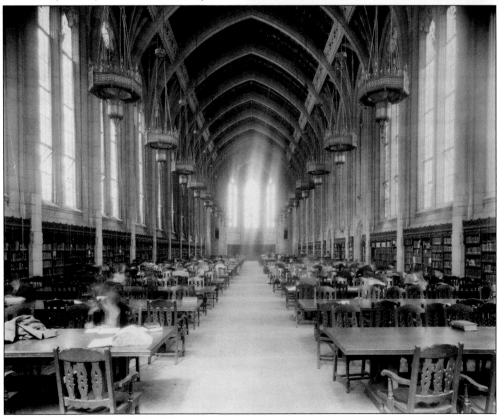

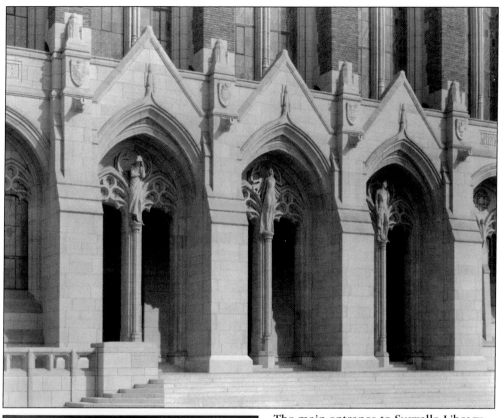

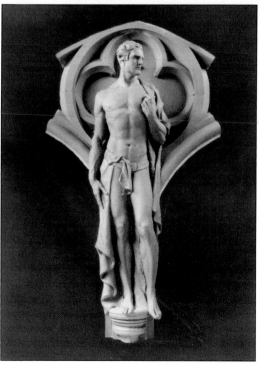

The main entrance to Suzzallo Library (above) features three sculptures intended to represent the stages of learning: Thought, Inspiration, and Mastery (from left to right). The photograph at left of the figure of Mastery shows the skill of the artist, Alan Clark of Tacoma. An additional 18 sculptures installed higher on the building's facade portray major contributors to learning and culture, as chosen by the faculty. They include figures from the ancient world—Moses and Homer—and more modern figures like Darwin and Pasteur. The sole American is Benjamin Franklin. The sculptures were made possible through a gift from Horace C. Henry, at the request of Henry Suzzallo. (Above, UWSC UW8862; left, UWSC Todd14335.)

Henry Suzzallo worked closely with two Washington governors: Ernest Lister and Louis Hart. The election of Roland Hartley as governor in 1924 marked a profound change. Hartley proposed a governmental reorganization that would reduce both the funding and the independence of the UW, which Suzzallo opposed. For that reason and others, Hartley replaced members of the university's board of regents until he had a majority who would dismiss Suzzallo. Many people who admired Suzzallo were outraged. The UW Alumni Association mounted a drive to recall the governor, but it failed. Suzzallo went on to head the Carnegie Foundation for Advancement of Teaching; nevertheless, he continued to consider Seattle his home. It was, he said, "the place of my best dreams." He died unexpectedly on a visit to Seattle in September 1933. The UW Alumni Association then successfully petitioned the board of regents—whose members had been appointed by a new governor—to name the library in honor of Suzzallo. (UWSC UW10513.)

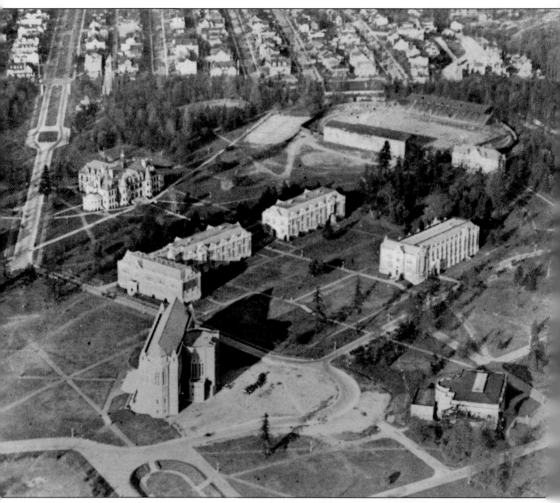

This aerial view of campus, taken around the time of Henry Suzzallo's dismissal, shows how much had changed during his presidency. Three of the buildings on the Liberal Arts Quadrangle had been completed—the ones now named Raitt, Savery, and Miller. Also complete was the library that would ultimately bear Suzzallo's name. The library appears at the bottom of the photograph, at the head of Rainier Vista. The brick buildings were designed to be fireproof, in contrast to the many temporary, often wooden, structures that existed when Suzzallo arrived in 1915. Denny Field can be seen at the top of this photograph, to the right of Denny Hall. A residential area, including fraternity and sorority houses, can be seen to the north of campus. Notably absent are the cherry trees that now bloom each spring in the Liberal Arts Quadrangle; they were not added until January of 1962. (UWSC UW20974z.)

Four

DEPRESSION AND WAR

The Roaring Twenties were underway when Matthew Lyle Spencer became president of the University of Washington in 1927, but the mood on campus was more subdued. The political tensions that accompanied Henry Suzzallo's dismissal were not limited to the governor and the president—they affected the legislature, faculty, students, alumni, and civic leaders. Within a few years, the dismissal crisis would pale in comparison to the worldwide economic depression that began in 1929 and lasted through the 1930s. At the UW, there were seemingly contrary developments: faculty salaries were cut as funding for operations was reduced, but an ambitious building program continued with state, federal, and private funds. Enrollment declined as students struggled to pay tuition, yet many alumni of that era remember New Deal programs that gave them paid work, which enabled them to complete their education. They found outlets for their youthful energy even in hard times. When the University of Washington varsity crew team won the gold medal at the 1936 Olympics in Berlin, it was a joyous moment that has never been forgotten.

Lee Paul Sieg took over as president in 1934. He led the university through exceptionally trying times: the worst years of the Depression, followed by World War II. Sieg believed in the value of what he called "trained minds," which is what the university could contribute to the state through both research and teaching. By the end of the 1930s, the challenges to the university changed as the world was once more engulfed in war. After the bombing of Pearl Harbor on December 7, 1941, students, faculty, staff, and administrators at the university became immersed in the war effort like the rest of the country. Many people expected that economic depression would return once the war ended, but those fears were not realized. When President Sieg retired in 1946, the university was about to embark on a remarkable period of growth.

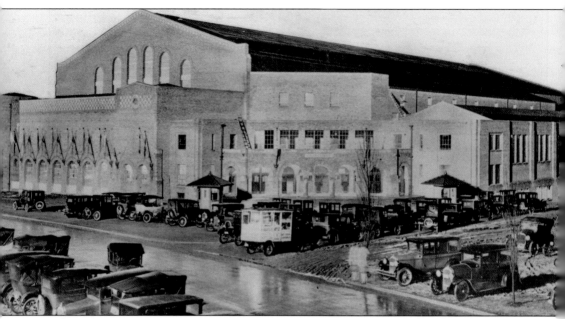

Matthew Lyle Spencer's inauguration as president (1927–1933) took place in the new Men's Athletic Pavilion (later renamed in honor of longtime basketball and track coach Clarence "Hec" Edmundson). Gov. Roland Hartley, whose handpicked regents had fired Henry Suzzallo, attended President Spencer's inauguration. Because athletics were still the responsibility of student government, the Associated Students of the University of Washington (ASUW) raised money for the Pavilion, which was part of the building boom that continued from the Suzzallo era into the 1930s. The Pavilion became the home not only to athletic events like basketball but also to convocations, commencement ceremonies, and conventions or trade shows sponsored by groups outside the university. Prior to construction of the Pavilion, the largest indoor gathering place on the Seattle campus was Meany Hall, known as the Auditorium when it was built for the 1909 Alaska-Yukon-Pacific Exposition. (UWSC UW6330.)

The UW was not yet known for its scholarship when national recognition came to faculty member Vernon Louis Parrington. In 1928, he won the Pulitzer Prize for history for his two-volume work *Main Currents in American Thought*. Parrington joined the Department of English in 1908, and was remembered by his students as a brilliant and provocative teacher. He died unexpectedly in 1929 while traveling in England. (UWSC UW9101.)

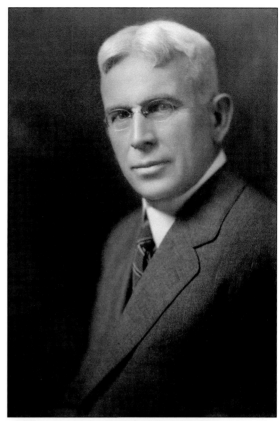

Other faculty members would gain national recognition for research on the languages, cultures, and traditions of the Pacific Northwest's native people. Two anthropologists, Melville Jacobs and Erna Gunther, became known for studying and preserving knowledge and ways of life that were rapidly disappearing. Jacobs is shown here using portable recording equipment to preserve the voice of Annie Miner Peterson of the Coos Tribe. (UWSC UW23239z.)

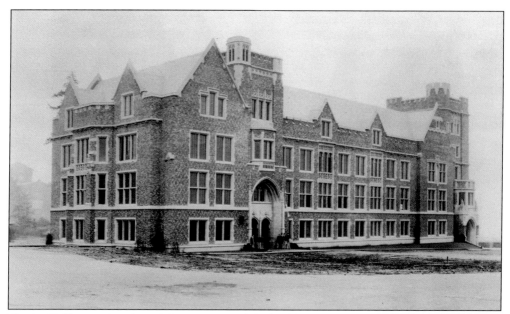

Physics Hall, completed in 1930, was part of the building boom that populated the Science Quadrangle with classrooms and laboratories. Along with Johnson Hall, completed in 1928 to house science departments, Physics Hall framed the top of Rainier Vista, as projected in the 1915 campus plan. In 1995, Physics Hall was expanded to serve as a center for undergraduate services and classrooms and renamed Mary Gates Hall. (UWSC UW14767.)

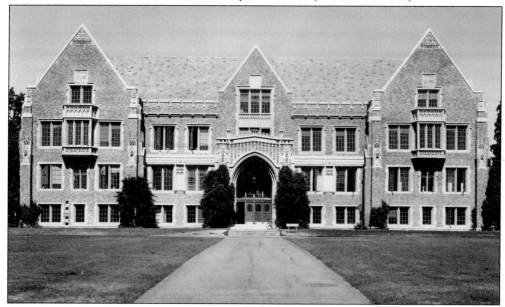

Guggenheim Hall, also part of the Science Quadrangle, was completed in 1929. The UW's relationship with William Boeing and his growing airplane company led the Daniel Guggenheim Foundation to provide funds for this building to "assist in making air transportation safe, popular, and regularly available." Originally housing several engineering departments, Guggenheim Hall is now home to the William E. Boeing Department of Aeronautics and Astronautics. (UWSC UW19805z.)

Another generous gift to promote the university's science programs came from the Rockefeller Foundation. In 1930, the foundation provided funds to build an oceanographic laboratory. At right, university president Matthew Lyle Spencer (left, front) celebrated the opening of the Oceanography Building with Dr. Robert Millikan of the California Institute of Technology (right, front) and other invited guests in 1932. Located on the Seattle campus behind the architecturally modern Health Sciences buildings, the Oceanography Building (below) is a rare example on the south campus of Collegiate Gothic architecture. The university's Oceanographic Laboratories, founded in 1930 and directed by professor Thomas G. Thompson, were the precursors of the School of Oceanography (now part of the College of the Environment). The school named its current oceangoing research vessel in honor of Thompson. (Right, UWSC UW20197z; below, UWSC UW20988z.)

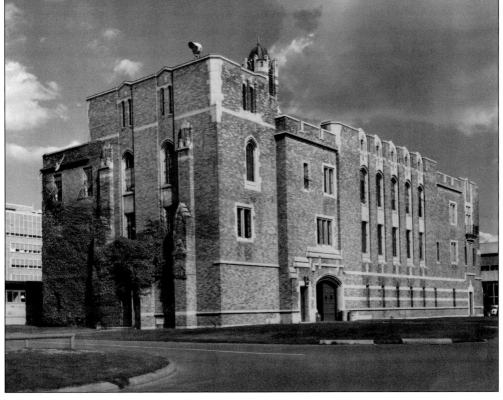

The economic depression was in full force when Lee Paul Sieg became president in 1934. He retired in 1946, having led the university through the crises of depression and war. During the darkest years of the 1930s, he had to defend the university's very existence. In the 1937 regents' report to the governor, Sieg wrote, "One may well ask point blank why we should show so much concern for the higher education of so many of these high school graduates . . . The State is only an aggregation of its people. If the people, by and large, are wise and intelligent, the State will reflect the same intelligence . . . It is, then, to the State's own interest to build its future right now." Sieg believed in the value of what he called "trained minds." He sought to coordinate the UW's teaching and research with the state's major industries, and worked with the governor and legislature to establish the UW schools of nursing, medicine, and dentistry. (UWSC UW3829.)

The University Book Store, shown at right in the late 1930s, was born of necessity in 1900. UW students had trouble getting textbooks, so the student government started a bookstore in Denny Hall. In 1925, the store moved to "the Ave," a block west of campus, and became a lively community resource attracting alumni and the general public, as well as students, by offering much more than textbooks. In-store events included a 1941 performance by Duke Ellington (below), as well as author readings and book signings. Now an independent corporation, the Book Store operates as a trust to benefit students, faculty, and staff, including providing annual rebates to patrons. With nine branch locations besides the Ave, the University Book Store is one of the most successful in the country. (Both, University Book Store.)

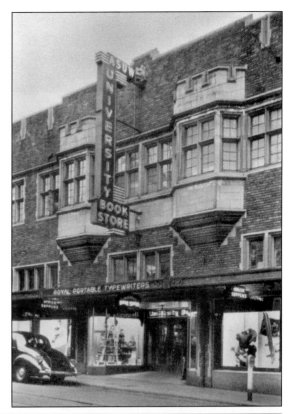

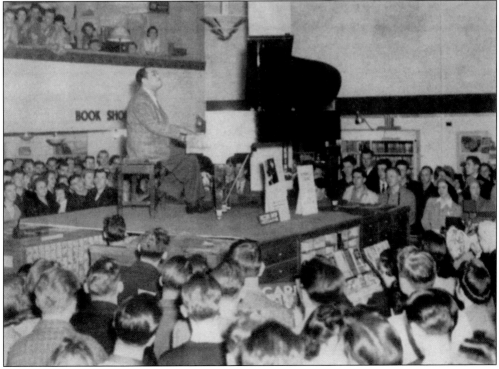

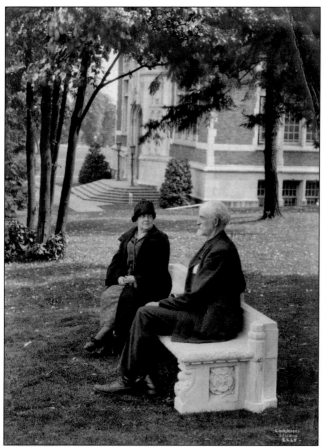

The photograph at left shows Edmond Meany and his wife, Lizzie, who both graduated from the Territorial University in 1885, on a bench in front of Denny Hall that is dedicated to their classmates. In 1935, Meany suffered a stroke and died at his desk in Denny Hall while preparing to teach a class. The death of Edmond Meany marked the passing of the generation whose roots went back to the university's early years. Even before Meany's death, many traditions he created and valued had disappeared. By 1934, the university decided that unemployed men should be paid for work that students had been doing, and Campus Day ended. The photograph below, taken on Campus Day in 1932, shows that students' youthful energy remained high despite the economic depression. (Left, UWSC UW534; below, UWSC UW22665.)

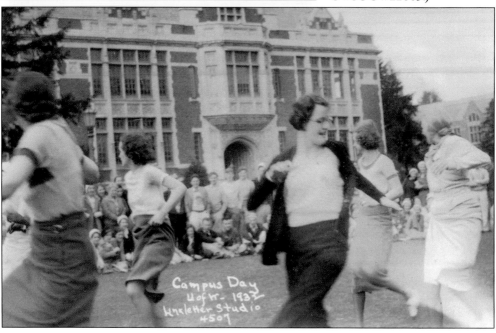

Trevor Kincaid, whose pioneer roots, like Edmond Meany's, extended back to the Territorial University, poses with students in his zoology class in 1935. Two years later he was subject to mandatory retirement at age 70, but his teaching and research continued. His impact on the state was recognized when the University of Washington Alumni Association chose him as the first recipient of its Alumnus Summa Laude Dignatus (ASLD) award in 1938. The ASLD remains the highest honor the university and the alumni association confer on a graduate. Among other achievements, Kincaid's experiments with Japanese oysters saved the state's oyster industry when the native oyster population of Willapa Bay was threatened with serious decline. Kincaid remained an active researcher until his death in 1970. Kincaid Hall, home of the Psychology Department on the Seattle campus, is named for him. (UWSC UW20330z.)

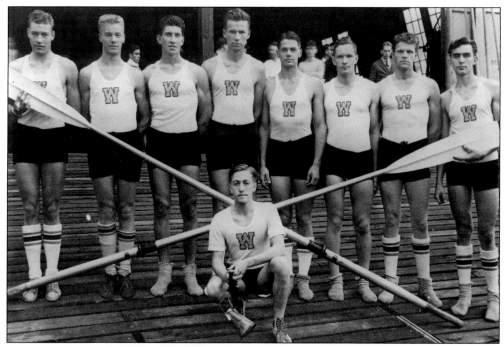

The UW has had many successful athletic teams, but its varsity crew became legendary after winning the gold medal at the 1936 Berlin Olympics. The athletes were working-class young men, suffering the economic hardships of the times. Competitive rowing had long been an elite sport, and other national teams had more financial support than Washington, which needed donations from alumni to travel to Berlin. Through hard work, excellent coaching, superior racing shells, and competitive drive, Washington's crew brought joy to its fans and glory to its school. Above, from left to right, are Don Hume, Joseph Rantz, George Hunt, James McMillin, John White, Gordon Adam, Charles Day, and Roger Morris. Coxswain Robert Moch is in front. The photograph below shows the close finish, with Washington's boat at the top. (Above, UWSC UW2234; below, UWSC UW1705.)

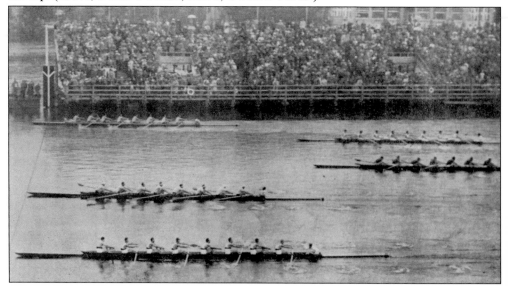

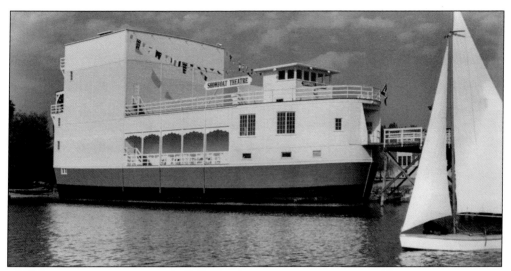

The School of Drama, directed by Glenn Hughes from 1930 to 1960, gained national recognition when the drama program was modeled after professional conservatories, with performances 52 weeks a year. Hughes experimented with theater-in-the round, and the UW's Penthouse Theatre, the first theater-in-the-round built in the United States, bears his name. The Showboat Theatre (above) was another experimental venue. Built on Portage Bay, on the south edge of campus, it appeared to float but was actually built on pilings. At the Penthouse and the Showboat, opening nights were formal affairs. Mayor (and later governor) Arthur Langlie is second from left in the photograph below, and Glenn Hughes is fourth from left, on opening night of the Showboat in 1938. (Above, UWSC UW9517; below, UWSC UW36081.)

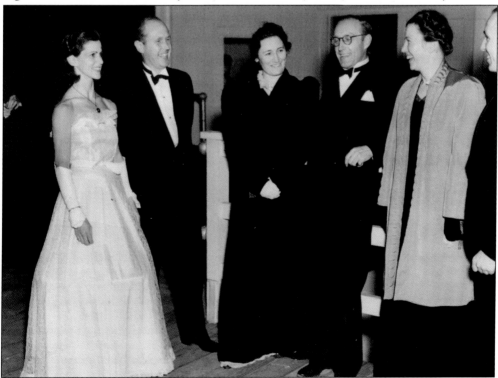

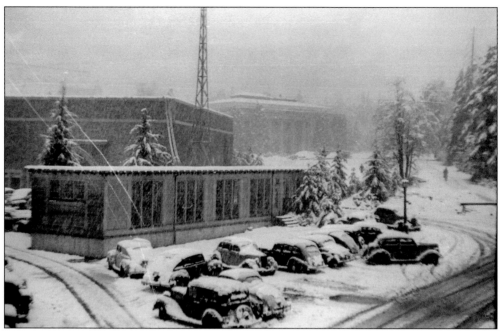

The 1946 photograph above of a snowy campus was taken from an engineering building. It shows two wind tunnels, both of which are still operating. The smaller building in the foreground was built in 1917, with funds from William Boeing, to help train engineers for his new company. The larger building behind it was built in 1938 with federal, state, and Boeing funds. It is named for professor Frederick Kirsten (at right in the construction photograph below). Kirsten joined the engineering faculty in 1920 and had a close working relationship with the Boeing Company. After World War II, Boeing constructed its own wind tunnel. The Kirsten Wind Tunnel is still in use as the University of Washington Aeronautical Laboratory (UWAL) for research, teaching, and academic and commercial testing. (Above, UWSC UW36021; below, UWSC UW36082.)

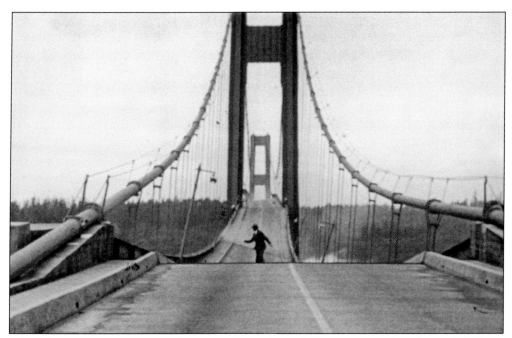

When the Tacoma Narrows Bridge opened on July 1, 1940, it was considered an engineering triumph, spanning a narrow wind-blown strait between Tacoma and the Kitsap Peninsula. The bridge soon became famous as "Galloping Gertie" for its tendency to sway and twist in the wind. This photograph of a man running from the bridge was taken shortly before it collapsed on November 7, 1940. (UWSC UW20731.)

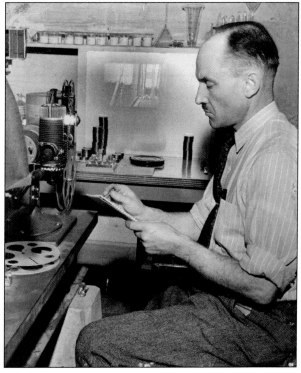

Professor F.B. "Burt" Farquharson led the team of engineers who analyzed the collapse. He had studied mechanical engineering at the UW, and later joined the faculty and became director of the Engineering Experiment Station. This photograph shows him studying film of the bridge's motion prior to its failure. He also built a wind tunnel specifically to test models. A new bridge opened successfully in 1950. (UWSC UW36022.)

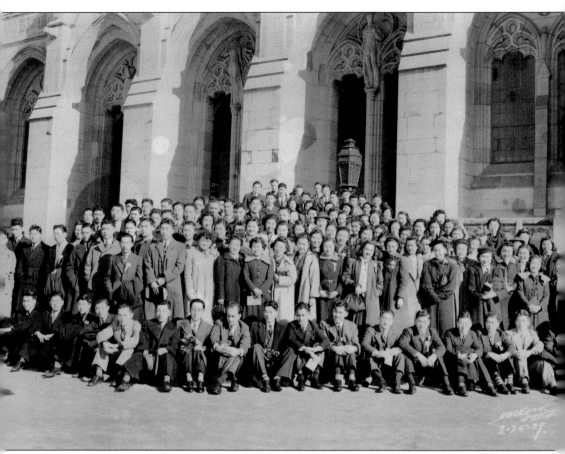

The UW has attracted students from Asia, and Americans of Asian ancestry, for much of its history. The group portrait above shows UW students of Japanese ancestry in 1939, gathered in front of Suzzallo Library. Although most were American citizens, they and other Japanese Americans were banned from the West Coast after the bombing of Pearl Harbor in December 1941 and sent to internment camps inland. President Sieg and other UW faculty and staff made active efforts to help students relocate to other colleges and universities away from the West Coast, where they would not be imprisoned. Some of those efforts were successful, but not all, and many students who had gathered for photographs like this each year went to internment camps with their families. Many others went into the military, even as their families were interned. (UWSC UW36067.)

Gordon Hirabayashi, seen at right in 2000, was a UW senior when Pearl Harbor was bombed. One of three Japanese Americans nationally to resist internment, he went to prison. Hirabayashi appealed his conviction to the US Supreme Court, but his appeal was denied. (In 1987, the Supreme Court overturned his conviction.) After World War II, Hirabayashi returned to the UW and completed bachelor's (1946), master's (1949), and PhD (1952) degrees in sociology. He had a successful academic career in Canada. In 2000, he was honored by the UW College of Arts and Sciences with an endowed professorship created in his name. In May 2008, the university gave honorary degrees to 449 Japanese American students whose education was cut short by internment; the surviving members of that group gathered in front of Suzzallo Library for the photograph below. (Both photographs by Karen Orders.)

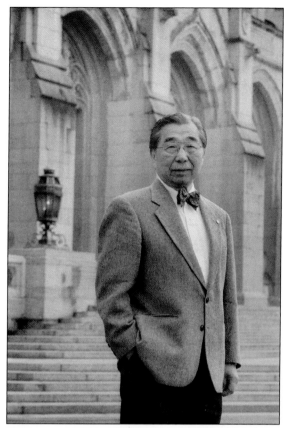

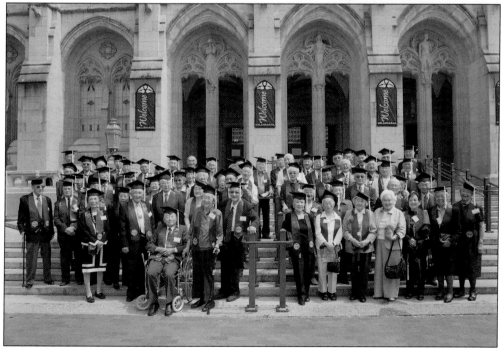

The attack on Pearl Harbor had a widespread impact on the university, as thousands of students, faculty, and staff members signed up for military service. Other members of the university community took jobs related to the war effort, some building airplanes and ships and some serving in civilian or government posts at home and abroad. The number of students registered for classes plummeted from more than 10,000 in the autumn quarter of 1939 to fewer than 5,000 by the autumn quarter of 1943. As the university focused attention on preparing students for military duty, it also hosted members of the military who were on campus for special training in languages, engineering, or other needed skills. Men, and sometimes women, in uniform became a familiar part of daily life on campus. This photograph, from the 1942 *TYEE* student yearbook, captures one such scene. (UWSC UW36072.)

This photograph shows electrical engineering students in 1943, when it was not unusual to see men in uniform in the classroom. A woman studying engineering was still a rarity at the time, even though women were taking on many jobs on campus and in industry that had previously been done primarily by men. The long-established partnership between the university and the Boeing Company became even stronger during the war, as faculty and students worked on engineering projects for military aircraft. Students also worked at war-related jobs, from building ships to harvesting apples in eastern Washington. When alumni from the war years collected memories from their classmates in preparation for their 50-year reunion in 1995, those memories often involved the struggle to balance a full-time class load with full-time off-campus work in support of the war effort. (UWSC UW36024.)

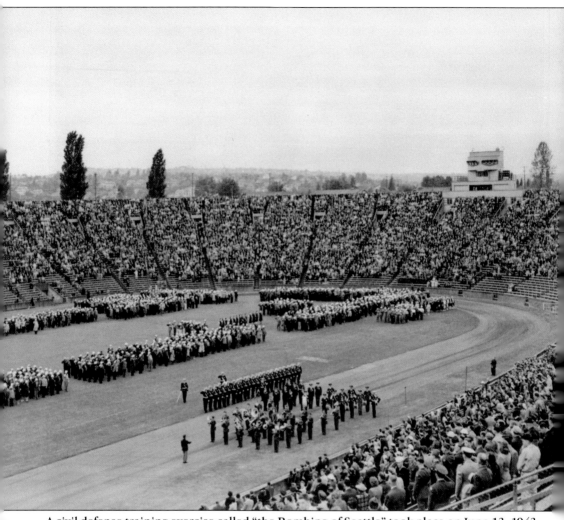

A civil defense training exercise called "the Bombing of Seattle" took place on June 13, 1943, at the UW. More than 35,000 people packed Husky Stadium for the event. The simulated attack began with thousands of civil defense volunteers, wearing white helmets and armbands, assembled on the field, where they marched to a military band, as shown here. The volunteers then took their seats in the stands, and tanks, jeeps, machine guns, and antiaircraft guns were brought out onto the field. A squadron of P-38 fighter planes roared overhead as soldiers fired blanks at them. As the planes went by, incendiary bombs placed in mock buildings on the field ignited, and firefighters took to the field to fight them. The event was meant to educate citizens about civil defense while also providing first responders an opportunity to practice teamwork. (UWSC UW36069.)

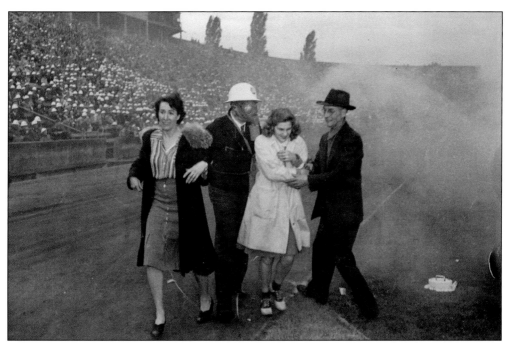

Seattle was considered a likely target of a Japanese air attack because of the concentration of defense industries in and near the city. In these photographs, civil defense workers aid "victims" of the fires, collapsing buildings, and gas attacks during "the Bombing of Seattle." Announcements over the public address system at Husky Stadium gave civilians instructions on what to do in case of fire or gas attack. The photograph below appears to be of a practice before the event, when no spectators were present. During the actual event, the P-38s returned several times, and more destruction ensued each time: there were fires, gas bombs, and TNT explosions in the mock village. The event concluded with the discovery and removal of an unexploded 500-pound bomb, which was driven around the track on a large truck while spectators applauded. (Above, UWSC UW36070; below, UWSC UW19059z.)

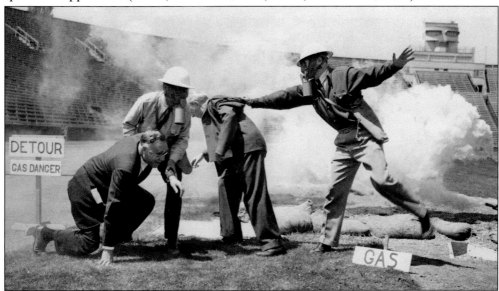

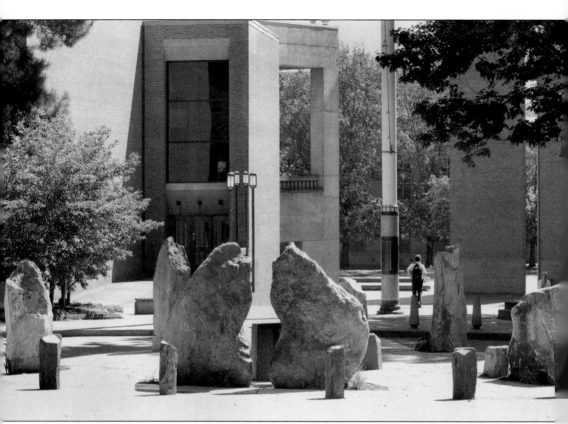

Nearly 600 University of Washington students, alumni, staff, and faculty lost their lives during World War II. Their names are inscribed on a plaque on the flagpole at the south end of Memorial Way on the Seattle campus, part of an artwork called *Interrupted Journey*. Alumni from the classes of the war years raised funds for the memorial and commissioned the artwork, with support from the University of Washington Alumni Association. North of the flagpole, a monument honors eight UW alumni who have received the Congressional Medal of Honor: Gregory "Pappy" Boyington, Deming Bronson, Bruce Crandall, Robert E. Galer, John D. "Bud" Hawk, Robert Leisy, William Kenzo Nakamura, and Archie Van Winkle. They served in World War I, World War II, the Korean War, and Vietnam. Both memorials—the plaque on the flagpole for World War II and the standing stones for the Medal of Honor—are visible in this photograph. (University Photography, DIG-2010-08-0074.)

Five

FROM GI BILL TO BABY BOOM

The GI Bill, officially named the Servicemen's Readjustment Act of 1944, offered education and housing benefits to veterans returning from World War II. The GI Bill transformed not only the veterans' lives but also higher education institutions like the University of Washington. Raymond Allen, the newly appointed president of the university in 1946, wrote in a report to the governor that enrollment had "doubled overnight." Equally important, Allen observed, was the "seriousness of purpose" that the veterans brought with them. They were eager to get on with life, and often chose degree fields they viewed as leading to immediate employment. "All in all," Allen concluded, "the veteran student has been an important factor in raising scholastic performance and has set a tone of maturity and seriousness that promises to have a permanent effect on University life." In response to the influx of students, temporary classrooms and temporary housing were everywhere.

The 1950s were a time of tremendous energy at the university, with new buildings going up, new programs like the School of Medicine and the School of Dentistry forming, and a new emphasis on research and graduate education, encouraged by both federal and state dollars. A student union building, the Husky Union Building, known as the HUB, opened in 1949. With meeting rooms, offices for student organizations, a cafeteria, and recreational facilities including a bowling alley, it gave students a place to gather on campus away from classrooms and libraries.

The 1960s began as an era of hope and enthusiasm, especially for young people. John F. Kennedy, in his presidential inaugural address, declared, "The torch has been passed to a new generation." The UW was preparing for its centennial celebration and planning for growth. With the first wave of postwar "baby boom" students due to arrive at the university in 1964, administrators estimated that the student body would increase from roughly 18,000 students in the autumn quarter of 1960 to 30,000 or more by 1970. The end of the decade would turn out to be "explosive" in ways that no one expected when it began.

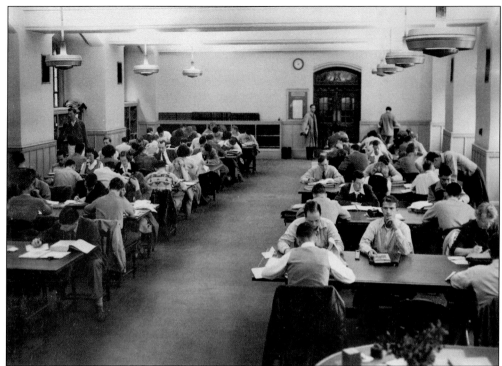

With the GI Bill bringing thousands of veterans to campus, the wartime absence of men in the student body was suddenly reversed, as shown in this 1945 photograph of students in Suzzallo Library. The veterans were older than most non-veteran students, many were married and had families, and they were serious about their studies. (UWSC UW20123z.)

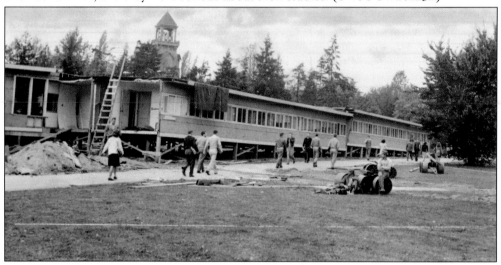

Temporary buildings were erected all over campus to provide housing and classrooms. A surplus Navy ship moored in Portage Bay, on the south edge of campus, was used as a dormitory and for classrooms. This photograph shows the demolition of temporary men's dormitories near Memorial Way. Although undated, the photograph was taken before the Chimes Tower, a beloved campus landmark visible behind the dormitories, burned down in 1949. (UWSC UW19775z.)

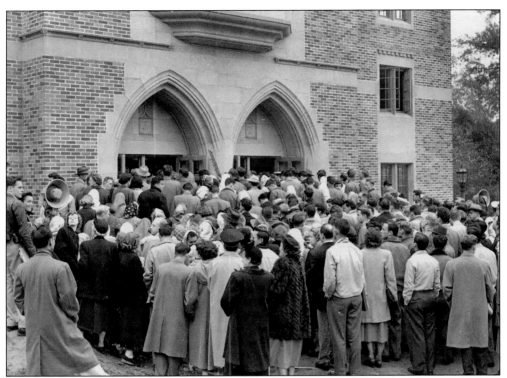

The new student union, the Husky Union Building, called the HUB, opened in 1949 on the site where the Forestry Building had stood during the Alaska-Yukon-Pacific Exposition. Above, crowds wait to enter the HUB on the day of the official opening. The HUB supplied much-needed food service for students in the cafeteria (below). It also provided offices for student government and other groups, and room for student activities. The HUB doubled in size in 1952, when a second wing was added and a new dining area called the Husky Den offered expanded food service. The building, including its food service and dining areas, has been expanded several times since then. The HUB closed in 2010 for extensive remodeling, reopening in 2012 to great acclaim. (Above, UWSC UW36068; below, UWSC Information Services 733H.)

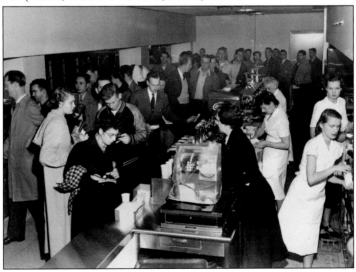

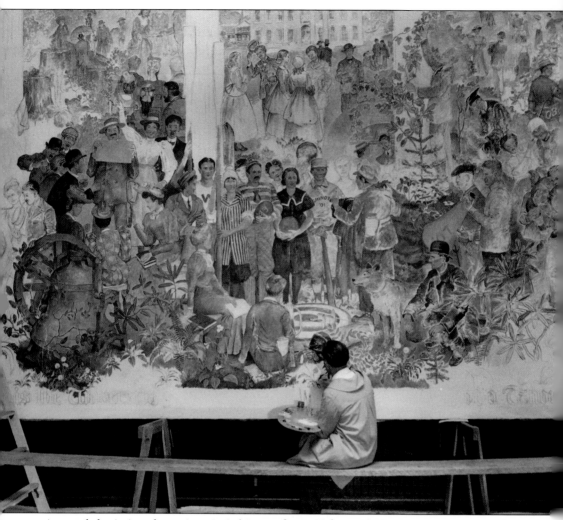

A mural depicting the university's history from 1861 to 1925 was commissioned for the new HUB. The artist was Ernest Norling, shown here painting the mural. People and views incorporated into the mural include: the original Territorial University building (cut off at the top of this photograph); Clara McCarty, the first graduate, receiving her diploma; the Denny Bell (bottom left corner), which had been moved from the original 1861 building to Denny Hall on the current Seattle campus; and a variety of student athletes and activities (center). Many native plants and trees found on the site of the 1895 campus were used as decorative elements in the mural. During the recent HUB remodel, the mural was cleaned and restored. It is mounted on the wall on the second floor of the HUB, with a printed guide in a display case explaining the historic scenes included by the artist. (UWSC UW19828z.)

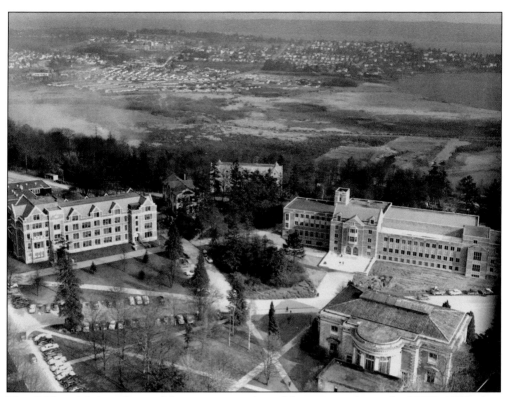

The 1955 aerial view above of the eastern portion of the campus shows the HUB's 1952 wing, visible on the right. In front of the HUB is a building from the Alaska-Yukon-Pacific Exposition of 1909 that had been pressed into service as the Washington State Museum. That building was later demolished, and the museum, now known as the Burke Museum, moved to a new building on Memorial Way. At the top of the photograph, in the area where students now park their cars or play sports, is the "Montlake Dump," which the City of Seattle used from 1926 until 1971 as a landfill for municipal garbage and construction debris, as shown below. (Above, UWSC UW19721z; below, UWSC UW19075z.)

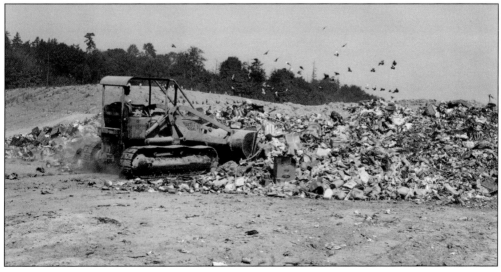

Raymond B. Allen (left) became UW president in 1946, the first physician in that role. He had been hired to oversee the new Health Sciences programs authorized by the legislature, but much of his administration was dominated by the activities of a committee headed by state representative Albert Canwell that in 1948 accused many UW faculty members of being communists. Three professors were fired as a result: Ralph Gundlach (Psychology), Herbert Phillips (Philosophy), and Joseph Butterworth (English). Another accused faculty member, Melvin Rader (Philosophy), was exonerated when a local journalist, Ed Guthman, proved that Rader had been falsely accused. Below, from left to right, Ralph Gundlach, his attorney John Caughlan, secretary for the local communist party Clayton van Lydegraf, and an unidentified man wait for a hearing by the board of regents in January 1949. (Left, UWSC UW10518; below, Post-Intelligencer Collection, Museum of History and Industry.)

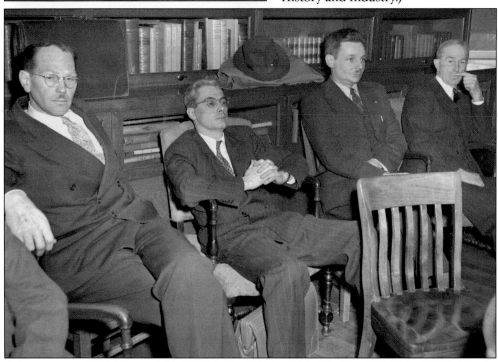

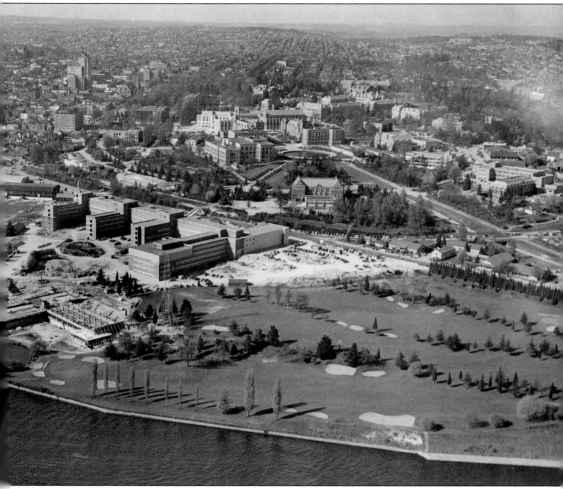

This 1949 aerial view of the campus shows the major development in the university's history after World War II: the emergence of Health Sciences programs, including the School of Medicine, the School of Dentistry, and the School of Nursing. The School of Pharmacy already existed, and two other schools would be added later: the School of Social Work (1958) and the School of Public Health (1970). The first wings of the new Health Sciences Center were built in the 1940s and 1950s along Portage Bay, on the university's golf course (seen in the lower portions of this photograph). The architecture was modern and functional, and the complex has continued to expand over subsequent decades. The original part of the Health Sciences building was later named to honor the late US senator Warren G. Magnuson, who steered a great deal of federal funding to the university's health sciences programs during his senate career (1944–1981). (UWSC UW2356.)

When the Department of Nursing became the School of Nursing in 1945, Elizabeth Sterling Soule (left) was named the first dean. Trained in public health nursing, she had led statewide efforts to deal with outbreaks of typhoid and tuberculosis in the 1910s, as well as the influenza epidemic of 1918. In 1922, she became head of the university's new Department of Nursing, then part of the College of Science. At the time, most nurses trained through hospitals. Soule combined university training with hospital training, leading to a bachelor of science degree. The four-year "integrated" nursing major that she developed became the national standard. The School of Nursing has been among the top-ranked nursing programs nationally since 1984. In the undated photograph below, Dean Soule is seated (front row, in black) with new graduates in their nursing caps. (Left, UWSC UW36079; below, UWSC UW29637z.)

Unlike the School of Nursing, the School of Medicine was created new. The first dean, Edward L. Turner MD, had considerable latitude in developing the school to coordinate with other science and professional programs at the UW. Dean Turner hired the founding faculty, shown above. (Turner is in the first row, third from right.) He also helped design and secure funding for new buildings. He is remembered by both colleagues and students for creating a culture that stressed hard work, integrity, and scientific curiosity. The photograph below shows the first class of medical students, who received their MDs in 1950. Many School of Medicine students were veterans in the early years, reaching a peak of 83 percent in the class of 1952. (Above, UWSC UW36076; below, School of Medicine.)

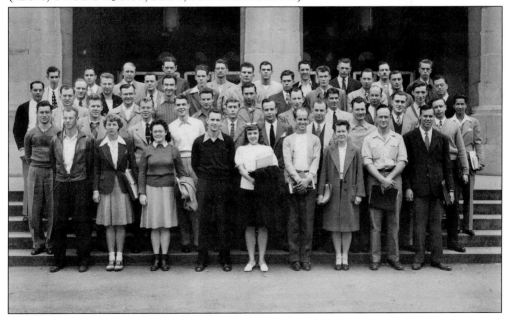

Like the School of Medicine, the School of Dentistry began training the first class of 50 students in temporary quarters while the Health Sciences building was being constructed. Dean Ernest Jones, seen at left with photographs of graduates of that first class, had come to Washington from the University of Southern California. He found that the newness of the school was a challenge in recruiting faculty, but also an advantage, as it provided a chance to start fresh. He declared that the new Health Sciences building would provide "the finest clinical facilities of any school in the world." All of the students in the first class, who graduated in 1950, were men; 48 of the 50 were veterans. Below, dental students treat patients in the new clinic around 1950. (Left, UWSC UW3058; below, UWSC UW20299.)

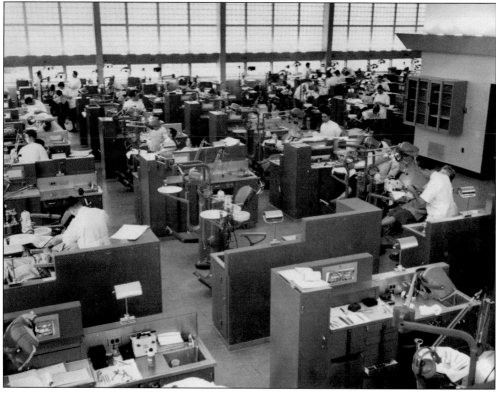

In 1956, construction began on the University Hospital (now the University of Washington Medical Center). The last remnant of the golf course (above) soon disappeared. University Hospital opened its doors on May 4, 1959, allowing medical students to get clinical training on campus instead of traveling to other hospitals. The photograph below shows the first surgery being performed at University Hospital. It was not the first surgery performed by faculty of the School of Medicine; they had been operating on patients at King County Hospital (now Harborview Medical Center, owned by the county and staffed by the university). Among early milestones achieved by UW faculty at King County Hospital was the Pacific Northwest's first open-heart surgery, performed in 1956 by a team of physicians and surgeons led by Dr. K. Alvin Merendino. (Above, UWSC UW6698; below, UWSC Information Services 5799a.)

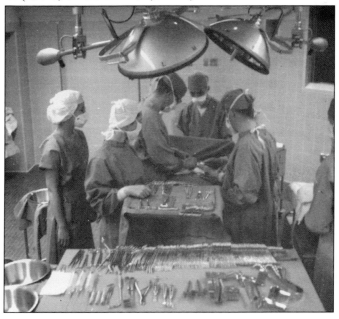

Theodore Roethke was a faculty member in the English Department from 1947 until his death in 1963. A brilliant poet and inspiring teacher, he was known for his stormy personality. Among his honors were the Pulitzer Prize for poetry (1954) and the National Book Award (1959). He began the university's Creative Writing Program, which continues to have distinguished poets on its faculty, including three MacArthur Fellows. (UWSC UW36020.)

George Tsutakawa, a painter and sculptor who attended the UW in the 1930s, is best known for his public works of art, especially fountains that combine American and Japanese sensibilities. After military service in World War II, he joined the School of Art faculty, where he taught for more than 30 years. (UWSC UW8937.)

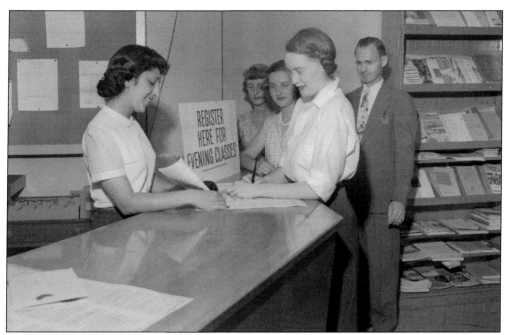

Evening classes were popular with working adults, like those shown above signing up in 1948. The UW had been offering Extension courses and other forms of outreach to people beyond the Seattle campus since 1912. Classes were available in person or by correspondence, and a speakers' bureau offered faculty expertise. After World War II, the Extension program (renamed the Division of Adult Education and Extension Services) expanded to carry the university to every part of the state. Through its performing arts programs, School of Drama students toured the state presenting live theater in schools and community centers. They traveled by bus, as seen below, carrying all their costumes and equipment with them. (Above, UWSC Information Services 2523A; below, UWSC UW36083.)

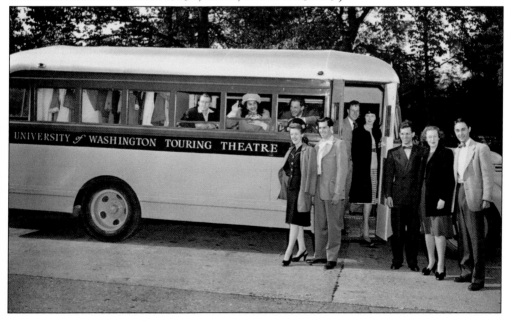

In 1960, lifesaving dialysis was available to only a few patients suffering from kidney failure. In Seattle, the decision of who would receive treatment was made by a panel of anonymous community volunteers, sometimes referred to in the media as the "Life or Death Committee." Long-term dialysis had only recently become possible because of an invention by School of Medicine professor Dr. Belding Scribner, shown here with a patient. The "Scribner shunt" was a U-shaped tube of Teflon permanently inserted in the patient's arm, allowing repeated dialysis. The device, developed by Scribner and colleagues including Dr. David Dillard and Wayne Quinton, saved lives but still required ongoing treatment in a clinical setting. Working with Scribner, professor Albert Babb and colleagues further advanced survival rates by creating a home dialysis unit, making treatment widely available—and the "Life or Death Committee" unnecessary. (UWSC UW36078.)

Another faculty member with a far-reaching impact was W. Thomas Edmondson. He joined the zoology faculty in 1949 and began studying local lakes, including Lake Washington. When that lake became visibly polluted in the 1950s, Edmondson provided the scientific background to help urge civic leaders and local voters to clean up the lake by creating a regional agency, known as METRO (right), to improve sewage treatment and transportation. The UW Alumni Association gave Edmondson its Outstanding Public Service Award in 1987, when the photograph above was taken. In his acceptance speech, Edmondson said, "As I see it, what a university professor is supposed to do is to find out about things and tell people about them. This is sometimes called research and teaching." (Above, University Photography; right, Municipality of Metropolitan Seattle (METRO) collection, Washington State Archives–Puget Sound Region.)

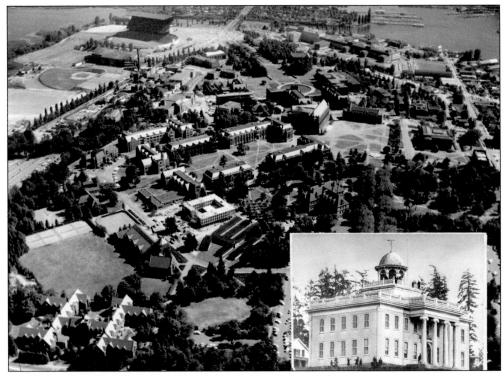

The University of Washington celebrated its centennial in 1961 with a yearlong series of events. The progress that the university had made was illustrated with the aerial photograph above, with the image of the Territorial University building in the inset. In honor of the centennial, regent Joseph Drumheller of Spokane donated funds to build a spectacular fountain in the middle of Frosh Pond on Rainier Vista. The combination of the fountain and the mountain, as seen below, is among the most iconic images of the university's Seattle campus. (Above, UWSC UW20977z; below, UWSC UW18028.)

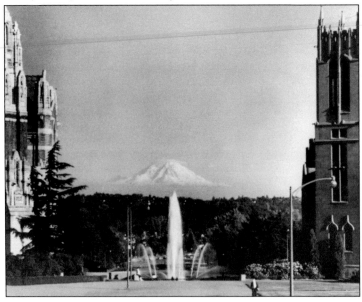

Pres. John F. Kennedy spoke at Hec Edmundson Pavilion on November 16, 1961, as part of the university's centennial celebration. Among the dignitaries on stage with him were US senators Henry Jackson and Warren Magnuson (above, second and third from right), and Gov. Albert Rosellini (third from left). At the UW, the future looked promising. Seattle was preparing to host the 1962 world's fair. The university was growing, adding programs and building classrooms, laboratories, and dormitories in anticipation of the baby boom generation that would soon arrive. The university was being led by a man who would turn out to be one of its greatest presidents: Charles Odegaard, who would serve for 15 years (1958–1973). Odegaard is sixth from the left above, just to the right of Kennedy. (Above, UWSC UW36023; right, UWSC UW6557.)

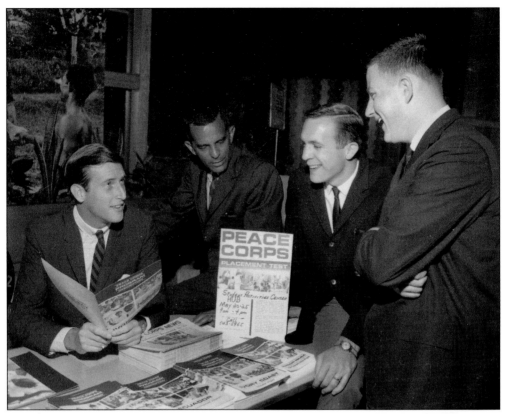

The Peace Corps, begun by Pres. John F. Kennedy, particularly appealed to young people, like those talking to a recruiter in this 1963 photograph. The Peace Corps training program at the UW was part of the Division of Adult Education and Extension Services (soon to be renamed Continuing Education). The sign in the photograph announces that a placement test will be given in the HUB. (UWSC UW20226z.)

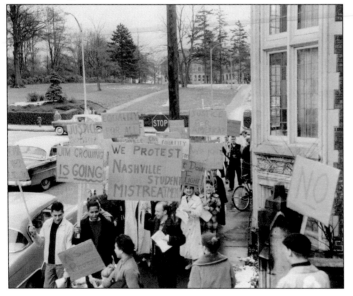

Students were becoming politically active in many causes, including the Civil Rights Movement. This 1960 photograph shows a protest march leaving campus in support of college students in Nashville, Tennessee, who were staging sit-ins to desegregate lunch counters. The group of marchers is small compared to groups that would gather by the end of the decade, as protests on a variety of issues erupted on campus. (UWSC UW17139.)

Six

WHEN EVERYTHING CHANGED

"The present university student generation does not look to me like a generation of lost and bewildered sheep; they seem hell-bent to take on not only the complexities of the university but also of the universe." These words, spoken by Charles Odegaard in 1965, reflect changes underway that would accelerate in the next few years. College campuses, including the University of Washington, were the site of escalating protests on many issues, especially opposition to the war in Vietnam, the fight for racial equality, and the women's liberation movement. In the midst of political and cultural disruptions, the UW campus was undergoing a physical transformation, with construction of new buildings for classrooms, libraries, dormitories, and health sciences programs. Everything seemed to be changing, though not always for the better.

By the time Charles Odegaard retired as president in 1973, the worst of the turbulence had abated, and the students threw a party for him on the new brick plaza in front of Suzzallo Library. Odegaard had served for 15 years, longer than any previous UW president. He was succeeded by John Hogness, former dean of the medical school, who had been the university's executive vice president during the turbulent years. In 1979, William P. Gerberding became president. He served for 16 years (1979–1995), during which many disruptions on campus came about because of state budget cuts, not national politics.

Despite budget challenges, changes that had roots in campus protests years before were becoming clearly visible. Both the student body and the faculty were more racially diverse, and there were more women on the faculty and in positions of administrative leadership. The university's private fundraising, which became a consistent effort beginning with the Alumni Fund in 1966, was growing. In 1989, the quality of research done at the UW was recognized when physics professor Hans Dehmelt became the first faculty member to receive a Nobel Prize. It was a symbol that the University of Washington had truly arrived on the world stage, with an impact far beyond the Pacific Northwest.

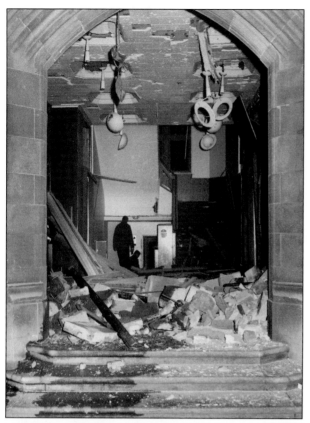

One of the most violent acts of a turbulent era took place on June 29, 1969, at 3:30 a.m., when a bomb exploded in the vestibule of the Administration Building (now Gerberding Hall). Damage was extensive, as shown in these photographs. No one was injured, but the blast made a gaping hole in the floor of the entryway and broke windows in the Administration Building, in Suzzallo Library, and in other nearby buildings. No person or group was ever identified as being responsible, nor was any motive found. President Odegaard described the "senseless destruction" as "an act of vandalism that defies understanding." Another violent act had occurred the previous year, when Clark Hall, home of the Naval ROTC program, was damaged by arson. Again, no culprit was identified. (Above, UWSC UW17032; below, UWSC UW20743z.)

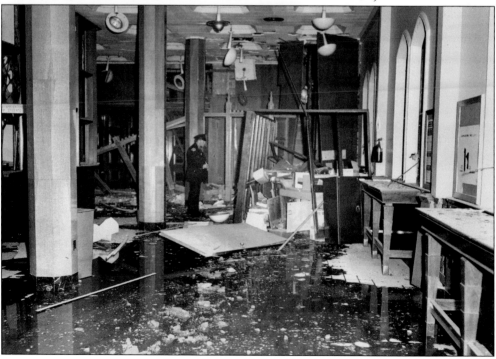

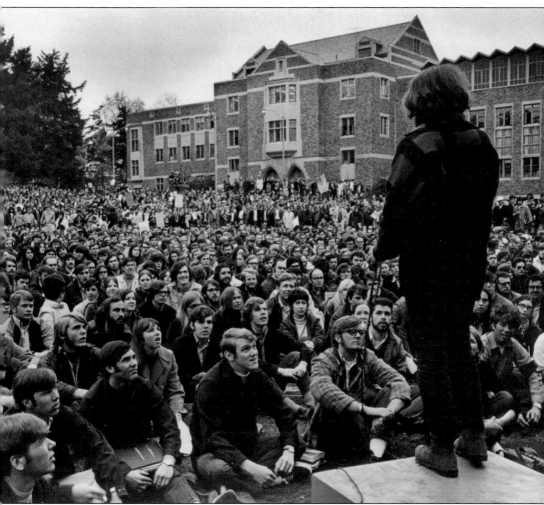

Opposition to the Vietnam War was the most visible issue of student protests, leading to mass gatherings on campus. The protests peaked in the spring of 1970 after the United States invaded Cambodia in an effort to disrupt supply routes used by the North Vietnamese army fighting in South Vietnam. Student leaders called for a strike on campus, but not one that would close the university. Above, students gathered on the HUB lawn to hear ASUW president Rick Silverman speak in May 1970. Students twice marched from campus to Interstate 5, on May 5 and 6, closing the freeway the first time but not the second. On May 8, Seattle mayor Wes Uhlman closed the freeway express lanes so that 15,000 demonstrators could march from campus to downtown. President Odegaard ordered the university closed twice that month (May 8 and 15), once after students were killed at Kent State University and again after students were killed at Jackson State, a historically black institution. (UWSC UW1840.)

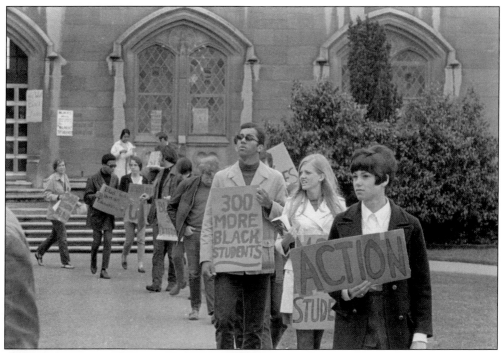

Protests also focused on increasing access for students from minority groups. The Black Student Union led on these issues, with support from many students and faculty, including demonstrations like the one above, held on May 10, 1968. On May 20, a large group of students, including African American, Latino, Native American, Asian American, and white students, entered the Administration Building and staged a sit-in at Odegaard's office. Among their demands were recruiting more minority students and low-income white students; changes to the curriculum, including courses in Black Studies; a resource center for minority students; and hiring more minority faculty, staff, and administrators. President Odegaard talked to the students in his office for hours and agreed to their demands. At left, E.J. Brisker, president of the Black Student Union, talked to the press afterwards. (Above, the *Seattle Times*; left, Post-Intelligencer Collection, Museum of History and Industry.)

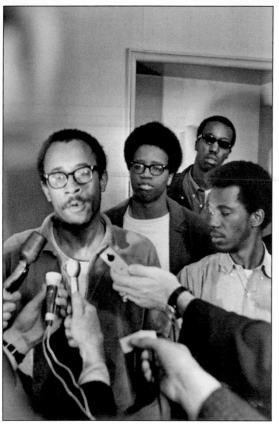

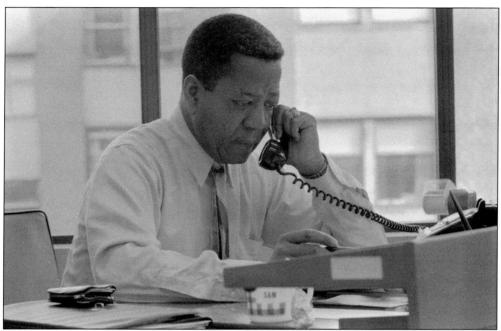

One result of the protest was the creation of the Educational Opportunity Program (EOP), to recruit and support minority students and low-income white students. In 1970, President Odegaard hired Samuel Kelly (above) as the first vice president for minority affairs. Kelly was a colonel in the US Army before beginning a second career in higher education. "Dr. Sam" led the Office of Minority Affairs (OMA) and the EOP through their formative early years. The Ethnic Cultural Center at the university is named for him. The 1971 photograph below shows Dr. Kelly (standing), with, from left to right, OMA division directors Mike Castillano, Emmett Oliver, Sam Martinez, and Larry Gossett. As a student, Gossett had participated in the sit-in at President Odegaard's office three years before; later, he entered politics, and he currently serves on the King County Council. (Above, University Photography, S13223-28a; below, University Photography M13313-4a.)

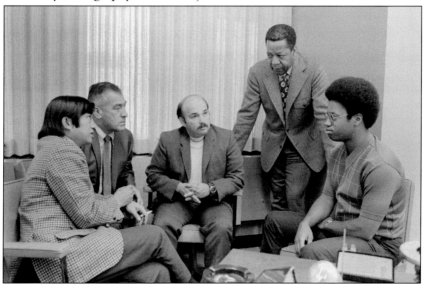

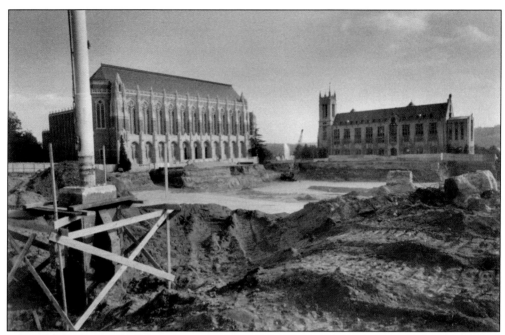

Political disruptions on the campus coincided with a massive building program. The photograph above shows the first phase of construction of a 1,000-car underground garage and three new buildings on the Central Plaza in front of Suzzallo Library. The excavation project replaced the green lawn with a massive hole, shown below, which students named "the pit." The construction site was the scene of protests, particularly over demands that minority contractors be hired for the project. Funding for this and other UW construction projects had been approved by the legislature and by a public vote on a bond issue during the 1960s, before campus disruptions and a severe downturn in the regional economy led to cuts in funding for the university. (Above, UWSC UW19676z; below, UWSC UW14630.)

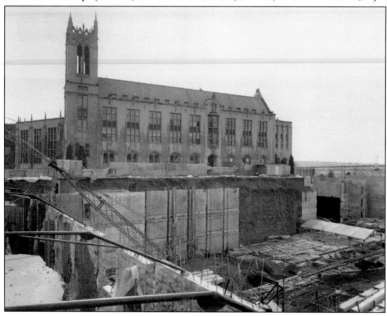

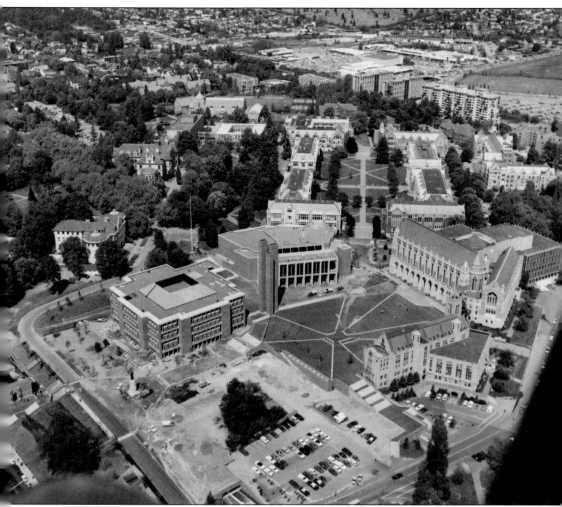

This 1971 aerial view of the Central Plaza shows the progress of construction. The underground garage was covered with a brick plaza, which students promptly dubbed "Red Square" because of the color of the bricks. As a crossroads between the Liberal Arts Quadrangle, shown at the top of this photograph, and the Science Quadrangle and Rainier Vista, Red Square is the scene of many formal and informal gatherings throughout the year. Two new buildings in this photograph are Kane Hall (to the left of Suzzallo Library), which contains lecture halls for large classes, and the new undergraduate library (to the left of Kane Hall), which would later be named for President Odegaard. Meany Hall for the Performing Arts would soon be constructed to replace the 1909 Auditorium (named to honor professor Edmond Meany in 1914), which had been severely damaged in a 1965 earthquake. A $20 million addition to the Health Sciences Center was also underway. (UWSC UW19623z.)

Not all UW students were involved in protests, and ordinary life went on amid the turmoil. Registering for classes was still done in person, and on paper. The students above are standing in line to register for the autumn quarter of 1969. A new wing of Suzzallo Library had opened in 1964 and was soon filled with students, as shown below. UW enrollment in the autumn quarter of 1969 had swelled to 32,749, almost twice what it had been a decade before. More than 60 percent of the students were men, and 8 percent were military veterans. (The number of military veterans would swell to 16 percent by 1972.) Graduate and professional programs accounted for nearly a quarter of the university's students in 1969, again with men greatly outnumbering women. (Above, UWSC UW20213z; below, UWSC UW20050z.)

When computers appeared on campus, they were large mainframes that required air-conditioned rooms. The photograph above shows the university's Computing Center in January 1965. Below, 20 years later, more people accessed and used computers, but most still relied on terminals connected to a mainframe. Computer Science was created as a graduate program at the UW in 1967 and expanded to include undergraduates in 1975. In 1989, Computer Science & Engineering became part of the College of Engineering; by then, computers had become an indispensable part of research, teaching, and learning throughout the university. (Above, UWSC Information Services 9472; below, University Photography L-8608415-10a.)

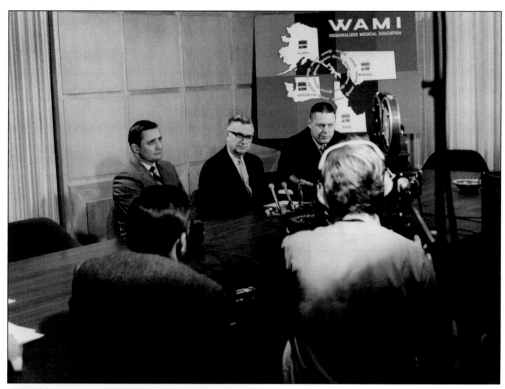

The university's health sciences programs continued expanding to serve a larger region. In 1970, the university announced a four-state medical education network called WAMI (Washington, Alaska, Montana, and Idaho). Washington had the only medical school in the four states. Through WAMI, medical students studied in their home-state universities for one year, moved to the University of Washington for their second year, and spent much of their third and fourth years and their residencies in communities similar to those in which they planned to practice. Wyoming later joined the network, now called WWAMI. Pictured above at the 1970 news conference are, from left to right, Dr. Roy Schwartz, first director of the WAMI program; President Odegaard; and dean of medicine Dr. Robert Van Citters. At left, a WAMI doctor in Alaska examines a young patient. (Above, UWSC UW32380; left, UWSC UW36036.)

Seattle's Medic One program has been saving lives since 1970, when professor Leonard Cobb and his colleagues wanted to see if non-physicians could provide emergency care outside of the hospital setting, primarily focusing on heart attacks. A group of Seattle firefighters received training, and a mobile van was outfitted with emergency equipment. Medic One vans like the one above became a common sight in Seattle and King County. Dr. Cobb, shown below inside a Medic One van, was director of cardiology at Harborview Medical Center at the time. (Harborview is owned by King County and staffed by the university.) The program later expanded to include training for paramedics, as well as training for individuals throughout the community—not just firefighters—in cardiopulmonary resuscitation (CPR). (Above, UWSC UW36086; below, © Philip Amdal.)

Campus turmoil led the University of Washington Alumni Association (UWAA) board of trustees to defend the value of higher education and students' right to free speech. The UWAA also sought to counter negative publicity with good news, including creating the Distinguished Teaching Award for faculty members. History professor Giovanni Costigan, seen above with students, received the first teaching award in 1970. He joined the faculty in 1934 and taught until his mandatory retirement at age 70 in 1975. Generations of students vividly remember Costigan's lectures on English and Irish history, and his genuine concern for his students. To allow him to continue teaching, and to reach a wider audience, the UWAA and the university's Continuing Education program sponsored public lectures on campus that attracted hundreds of people, as shown below. (Above, University Photography M16154-34a; below, University Photography M16155-27.)

Economics professor Henry Buechel received the Distinguished Teaching Award in 1971, the second year it was given. He taught introductory courses, large lecture classes that were so popular that students sometimes invited their friends and even their parents. This photograph was taken on the most famous day of his teaching career: February 11, 1970. As part of a coordinated strategy of class disruptions, a protester rose in his Economics 200 class demanding that Buechel talk about "more important things" like the war in Vietnam. Professor Buechel ordered the protester out and invited students in the class to help him physically evict the young man. Students rallied to support their teacher, and the protester left. After Henry Buechel died in 1972, gifts from past students created an endowment in his name in the Department of Economics to honor and encourage outstanding teaching. (UWSC UW36012.)

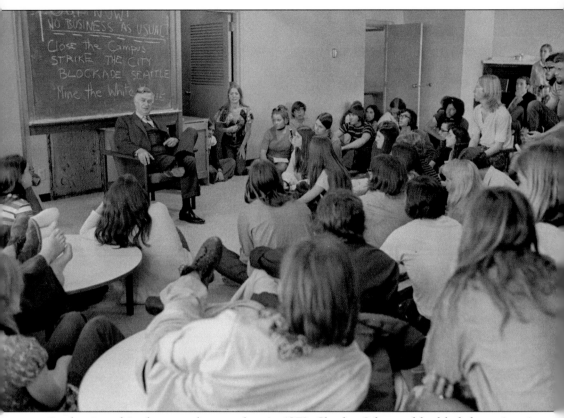

By the time this photograph was taken in 1972, Charles Odegaard had led the university through an extraordinary number of changes. He arrived in 1958, the year after the launch of the Sputnik satellite by the Soviet Union made higher education part of national defense. He had overseen rapid growth to prepare for the arrival of the baby boom generation. Dealing with campus disruptions in 1970, he issued a statement that said, in part: "So many conflicting opinions advanced with such high emotional intensity by so many people cannot be stirred up merely by a simple issue for which there is an easy and obvious answer." In response to criticism, he defended students' right to free speech and said "I am not a prison warden." This photograph of Odegaard meeting with students in the then-new (now demolished) Lander Hall dormitory shows him willing to listen to students whose ideas, written on the blackboard, he disagreed with. No one could doubt that he was clearly in charge. (University Photography 14298-18.)

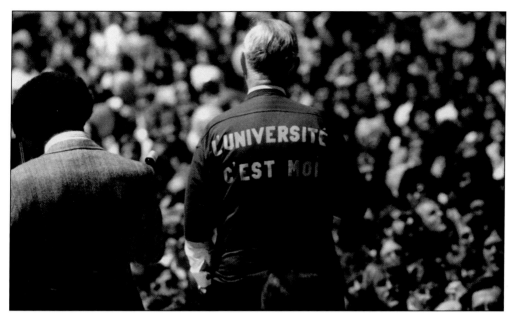

In May 1973, an unusual notice appeared in *The Daily*: "Charles Odegaard has lived through 15 years of riot, famine, pestilence, the Legislature, the faculty, budget cuts, lawsuits and swarms of uppity students. Let's do something to make it up to him." Some 5,000 students joined faculty, staff, legislators, and community members at a retirement party for Odegaard on Red Square. Students presented him with a purple and gold sweatshirt (above); paraphrasing Louis XIV, it read, "L'université c'est moi." Odegaard disagreed, saying, "The university is us." The student body president announced that the new undergraduate library would be named for Odegaard. The architecture, with the signature staircase (below), was dramatic. The library has since been remodeled to optimize the learning spaces for study and research, and to accommodate students' need for computers and classrooms as well as books. (Above, University Photography M14954-15; below, UWSC UW20274z.)

When John Hogness succeeded Charles Odegaard as president, some of the challenges he faced were rebuilding trust with people outside the university and rebuilding morale among the faculty. The first was addressed in part through a public relations campaign with the tagline "The University of Washington. You're Getting Something Out of It Whether You Go There or Not." Examples ranged from medical care to the arts. The second challenge led to the creation of the Faculty Lecture, by which a current or emeritus faculty member was chosen by colleagues to deliver a public lecture. This came with an honorarium provided by gifts to the university. The first Faculty Lecturer, in 1976, was Hans Neurath, founder of the Department of Biochemistry. The second was historian David Pinkney. Artist Jacob Lawrence, who joined the faculty in 1974, was chosen as the third Faculty Lecturer in 1978. Lawrence is seen here painting in his studio. (UWSC UW29653z.)

William P. Gerberding became president of the university on July 1, 1979. He is seen at right leaving Denny Hall during a tour of campus. Below, dignitaries gathered at his formal inauguration included Gov. Dixy Lee Ray, standing next to Gerberding (far right). Ray, the first woman elected governor of Washington, was a former UW faculty member. Gerberding's plans for the UW's future were soon disrupted by state and national economic problems. In September 1981, the board of regents declared a financial emergency as a result of state budget cuts. Programs deemed not essential to the university's core mission were eliminated or cut back. It was a difficult time, and restoring the physical, financial, and human resources of the university would take years. (Right, © Bob Peterson; below, University Photography F17448-19A.)

In November 1989, physics professor Hans Dehmelt became the first UW faculty member to win a Nobel Prize. Dehmelt joined the faculty in 1955 and spent his entire career at the UW, retiring in 2002. His Nobel Prize award cited "his pioneering achievements in perfecting electromagnetic traps for precision studies of single ions, electrons and positrons, culminating in the measurement to unprecedented accuracy of the magnetism of the free electron." Above, Dehmelt (right) speaks at a news conference on the day the prize was announced. With him are Pres. William Gerberding (left) and Department of Physics chair Mark McDermott. The large turnout for the press conference, as seen below, demonstrated the excitement among journalists at the news of the Nobel Prize, which affirmed the UW's growing reputation as one of the nation's leading research universities. (Above, University Photography ML8910683-28; below, University Photography ML8910682-36.)

The UW started with a gift in 1861, but it took more than a century before a consistent effort to seek private donations began, with the launch of the Alumni Fund in 1966. Fundraising gained momentum with the creation of the University of Washington Foundation in 1988. The foundation's board of directors, seen here, included alumni, corporate and civic leaders, and UW officials. The university-wide Campaign for Washington (1987–1992) raised $284 million, almost half of it for endowments to support faculty, students, and programs throughout the university. Gifts for current use supported facilities, equipment, students, faculty, and programs. The Boeing Company, which had long been the university's top donor, maintained that position during the Campaign for Washington with gifts that included endowments to support faculty and graduate students. In a sign of changes in the local economy, Microsoft cofounders Bill Gates and Paul Allen were also among the top donors to the campaign. (University Photography L8810658-8.)

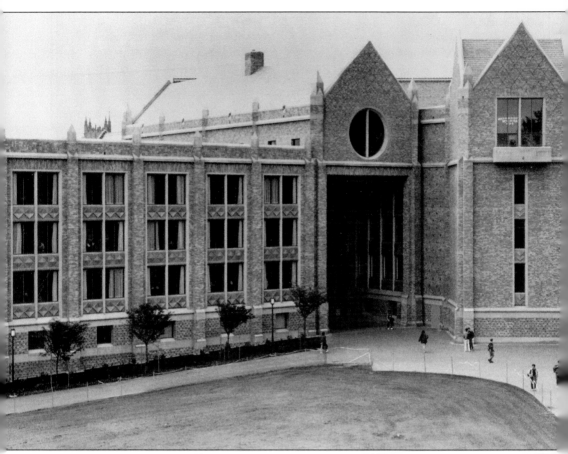

The Kenneth S. Allen Library, seen here, became a symbol of the Campaign for Washington and its impact. A gift of $10 million from Microsoft cofounder Paul Allen was announced in October 1988, when construction for a major expansion of Suzzallo Library was beginning. Allen made the gift to honor his late father, Kenneth S. Allen, who had been a librarian at the university for 30 years and was associate director of the University of Washington Libraries for 22 years. Most of the gift created the Kenneth S. and Faye G. Allen Endowment, named for Allen's parents, which supports library programs and acquisitions. Approximately $2 million went toward supplementing state funds for the building. The Allen Library added 215,000 square feet to the university's main library and created many improvements, including expanded facilities for the University of Washington Libraries Special Collections Division. (UWSC UW19970z.)

Seven

PIONEERING INTO A NEW CENTURY

A new era in the university's history began in 1990 when branch campuses opened in Tacoma and Bothell. Initially intended to serve students who had attended community colleges and wanted to complete a bachelor's degree, the Tacoma and Bothell campuses soon evolved to offer full four-year degrees and master's degrees. Each of the new campuses also developed its own identity and sense of community.

Expanding access to the university's Seattle campus and encouraging talent where it might have been overlooked also took on new forms, like the Dream Project. Initiated by a first-generation college student to help other first-generation and low-income students navigate the path to higher education, the Dream Project is student-led and student-run. It connects more than 500 UW students with teens in 16 local high schools.

Now a major research institution in ways that its founders could not imagine, the UW retains a spirit of entrepreneurial "go-aheaditiveness." Many of the university's research and education programs have helped to fuel the region's economy, leading to hundreds of new businesses and providing an educated workforce. Internationally known research projects range from studies of early learning that look inside babies' brains as they develop to environmental research from the Arctic to the depths of the oceans. UW health sciences programs have expanded beyond serving the state and region to addressing global health problems. The growth of private giving to the university increasingly reflects a sense of partnership with alumni, friends, corporations, and foundations. From 2000 to 2008, Campaign UW: Creating Futures raised $2.68 billion to support people, projects, and buildings on the university's three campuses.

To celebrate all that has been achieved in its first 150 years, the university created "W Day," a birthday party held on November 4, 2011. The celebrations on the UW's three campuses included cupcakes, music, commemorative tee shirts, face painting, and other party activities. Alumni around the globe were invited to join by wearing the UW colors, purple and gold. Students, faculty, staff, alumni, and friends enjoyed the celebration so much that W Day became a new tradition, part of homecoming weekend.

When the University of Washington Tacoma opened in 1990, the area in this photograph was a collection of run-down industrial buildings that the university chose to renovate rather than tear down. Classes began in rented office space nearby, while the century-old brick buildings were transformed. Former warehouses became classrooms and offices, a former power plant became the library, and, in 1997, the permanent campus opened. Since then, many new buildings have been added, the student body has grown to more than 4,000, and the curriculum has expanded. Initially offering junior- and senior-year degree-completion classes, plus some master's degrees, UW Tacoma accepted its first freshman class in 2006 and now offers four-year bachelor's degrees. In 2013, its graduate programs expanded to include a doctoral program in Educational Leadership. The repurposed 46-acre campus and strong community partnerships have helped UW Tacoma serve as a change agent not only for its students but also for the region. (UW Tacoma.)

The University of Washington Bothell also began classes in 1990, in rented space. By 2000, new construction transformed its 128-acre home from a cattle ranch to a modern campus, shared with Cascadia Community College. The UW Bothell campus includes one of the state's largest restored wetlands, which students like those pictured below use for environmental research and interdisciplinary projects, from art to interactive media design. UW Bothell's emphasis on environmental sustainability—in its curriculum, buildings, and campus landscaping—complements its emphasis on science, technology, engineering, and mathematics (STEM) courses that prepare students to work in high-tech industries nearby. With more than 4,600 students pursuing four-year bachelor's degrees or master's degrees, UW Bothell is growing fast, attracting a diverse student body while nurturing a strong sense of community through small classes and student activities. (Both, UW Bothell.)

Alula Asfaw (above, left) knows it can be hard for students whose parents lack college degrees to navigate the path to higher education. A first-generation college student, Asfaw and some of his fellow students wanted to help other first-generation and low-income students. The result is the Dream Project, a student-led, student-run program that combines outreach to local high schools, peer mentoring, scholarships, and a supportive community for new students admitted to the UW. More than 500 UW undergraduates participate in the Dream Project, 60 of whom run the program in every aspect from mentoring to fundraising to outlining goals for the future. Students also participate in coursework that provides context on social and educational issues. The students' enthusiasm, reflected below, comes from their own life experience and the satisfaction of helping others. (Both, the Dream Project.)

The UW granted its first PhD in 1914, and it now awards more than 700 doctoral degrees each year. Students like Carolyn Valdez (right) and Hilary Palevsky (below) are pursuing PhDs with help from the ARCS Foundation Seattle. ARCS (Achievement Rewards for College Scientists) is a nationwide volunteer network of women dedicated to advancing science in America by providing graduate fellowships in science, engineering, and medical research. Valdez, pursuing a PhD in chemistry, studies the fundamental chemistry of metal oxide nanoparticles. Among other uses, her research can help improve solar cells. Palevsky, pursuing a PhD in oceanography, studies how the North Pacific absorbs carbon dioxide from the atmosphere. ARCS Foundation Seattle has supported hundreds of UW students like these since the first ARCS fellowships were awarded in 1978. (Both, UW Graduate School.)

When Mark Emmert and Linda Buck graduated from the UW in 1975, neither could imagine their future return. Emmert became president of the university in 2004, the same year that Buck, a faculty member, received the Nobel Prize in Medicine or Physiology. When Emmert hosted a dinner for Nobel laureates on the UW faculty, it turned out that the other Nobel recipients in attendance had been at the university when Emmert and Buck were undergraduates. Above, Emmert (left) and Buck (center) join Provost Phyllis Wise. Below, Buck is with, from left to right, Hans Dehmelt (1989 Nobel in Physics), Edwin Krebs (1992 Nobel in Medicine or Physiology), and E. Donnall Thomas (1990 Nobel in Medicine or Physiology). Thomas did his Nobel Prize–winning research at the Fred Hutchinson Cancer Research Center, where Buck is a research scientist. (Above, University Photography ML20060248-11; below, University Photography ML20050288-04.)

The Department of Global Health, created in 2007 with a gift from the Bill & Melinda Gates Foundation and state funding, draws on expertise from across the UW to help understand and improve the health of people around the world. Above, a researcher from the Institute for Health Metrics and Evaluation—also created at the UW through a gift from the Gates Foundation—collects data in Bangladesh in 2009 for the institute's Global Burden of Disease study. Below, graduate student Clarissa Lord Brundage poses with midwives in Côte d'Ivoire. Brundage received a scholarship from the Department of Global Health to work with midwives on a family planning project with Health Alliance International, a nongovernmental organization founded by UW faculty in 1987. (Above, Institute for Health Metrics and Evaluation; below, photograph by Mohammed Coulibaly.)

The Pacific Northwest has become broadly identified with computers, software, and high technology. The university's Department of Computer Science & Engineering is both a source and a beneficiary of the innovations that have transformed daily life. One of the top 10 computer science programs in the country, its faculty have won numerous national and international awards for their research, as well as distinguished teaching and mentoring awards from the UW. In October 2003, the department moved into a new home, the Paul G. Allen Center for Computer Science & Engineering, seen here, that reflects its creative, collaborative spirit and its close connections with regional entrepreneurs. The building, designed by Seattle's LMN Architects, was a public-private partnership among the State of Washington, the university, and more than 250 friends and alumni. (Photograph © Lara Swimmer; courtesy of LMN Architects.)

Many of the university's current research programs have attracted worldwide attention, including one that focuses on the earliest learning: watching a baby's brain as the infant develops. The Institute for Learning & Brain Sciences (I-LABS) is an interdisciplinary center dedicated to discovering and sharing the core principles of human learning. In 2010, I-LABS added a new research tool, a specially designed "MEG" (magnetoencephalograpy) machine (above) that can track brain responses in infants and young children as they listen to language and do other mental tasks. Acquisition of the machine was made possible by a combination of state funds and private support. Below are I-LABS codirectors Patricia Kuhl (left) and Andrew Meltzoff (right), along with university president Mark Emmert and Washington governor Chris Gregoire at the dedication of the I-LABS MEG Brain Imaging Center. (Both, I-LABS.)

The College of the Environment, created in 2009, brings together many of the university's departments and programs to focus on understanding the interaction between Earth's environment and human activities. Above, an international team of researchers, including some from the college, gets ready to launch a weather balloon in the Arctic to understand the processes by which radiation leaks from high altitude down to the upper atmosphere. At the opposite extreme, oceanography faculty and UW's Applied Physics Lab are installing an underwater cabled observatory off the Oregon coast to provide power and communication to sensors to investigate an active volcano, hot vents, earthquakes, and processes throughout the full ocean water column. Below, sulfide chimneys vent 700°F fluids at a depth of 7,000 feet. (Above, photograph by John G. Sample; below, composite photograph by John Delaney, Deborah Kelley, and Mitch Elend.)

The UW business school was named the Michael G. Foster School of Business in 2007, in recognition of gifts from the Foster Foundation. Three years later, the Foster School moved into an elegant new building, PACCAR Hall, also made possible by gifts from alumni, friends, corporations, and foundations in the community. The impact of the gifts goes beyond bricks and mortar, creating a sense of community and a gathering place for people and ideas. Collaboration and teamwork are evident throughout PACCAR Hall: in the open atrium, in the 28 student team-meeting rooms that complement larger classrooms, and in the technology that facilitates learning and sharing by computer and mobile devices throughout the Foster School. (Photograph by Paul David Gibson.)

When the university celebrated its 150th anniversary on November 4, 2011, it launched a new tradition: W Day. A party on Red Square featured the UW marching band and cheerleaders, birthday cupcakes, and commemorative tee shirts. Students, faculty, staff, alumni, and friends enjoyed the celebration, despite some drizzle. (Yes, it does rain in Seattle.) W Day has since become a yearly event, held during homecoming weekend. Here, UW president Michael K. Young (center right) poses for a photograph at the 2013 celebration with University of Washington Alumni Association executive director Paul Rucker (center left) and student government representatives (from left to right) Taylor Ahana, Jeffrey McNerney, Kelli Feeley, and Shivani Changela. In 2014, W Day will help celebrate the 125th anniversary of the founding of the UW Alumni Association, which began with 60 living alumni in 1889. There are now more than 330,000 living alumni. (Photograph by Katherine B. Turner/UW Marketing.)

BIBLIOGRAPHY

Web resources:

www.lib.washington.edu/specialcollections/research/digital-collections-and-exhibits. Digitized materials such as photographs, yearbooks, maps, newspapers, posters, reports, and other media selected from University of Washington Libraries Special Collections holdings.

Printed materials:

Bromberg, Nicolette, Frank H. Nowell, and John Stamets. *Picturing the Alaska-Yukon-Pacific Exposition: the Photographs of Frank H. Nowell*. Seattle: University of Washington Press, 2009.

Brown, Daniel James. *The Boys in the Boat: Nine Americans and Their Epic Quest for Gold at the 1936 Berlin Olympics*. New York: Viking, The Penguin Group, 2013.

Cullen, Thomas J. and Kathryn Sutton Cullen. *The Obituaries of University of Washington Presidents 1861–1958*. Seattle: The Northwest Center for Studies in Education, 1989.

Daves, Jim and W. Thomas Porter. *The Glory of Washington: The People and Events That Shaped the Husky Athletic Tradition*. Champaign, IL: Sports Publishing Inc., 2001.

Dorpat, Paul. *University Book Store: A Centennial Pictorial*. Seattle: University Book Store, 2000.

Finch, Clement A. *Fulfilling the Dream: A History of the University of Washington School of Medicine, 1946–1988*. Seattle: Medical Alumni Association, University of Washington School of Medicine, 1990.

Gates, Charles M. *The First Century at the University of Washington, 1861–1961*. Seattle: University of Washington Press, 1961.

Illman, Deborah L. *Pathbreakers: A Century of Excellence in Science and Technology at the University of Washington*. Seattle: Office of Research, University of Washington, 1996.

———. *Showcase: A Century of Excellence in the Arts, Humanities, and Professional Schools at the University of Washington*. Seattle: Office of Research, University of Washington, 1997.

Johnston, Norman J. *The Fountain and the Mountain: the University of Washington Campus, 1895–1995*. Woodinville, WA: Documentary Book Publishers Corporation, and Seattle: University of Washington, 1995.

Porter, W. Thomas. *Go Huskies! Celebrating the Washington Football Tradition*. Chicago: Triumph Books, 2013.

Sanders, Jane. *Cold War on the Campus: Academic Freedom at the University of Washington, 1946–64*. Seattle: University of Washington Press, 1979.

———. *Into the Second Century: the University of Washington, 1961–1986*. Seattle: University of Washington Press, 1987.

DISCOVER THOUSANDS OF LOCAL HISTORY BOOKS
FEATURING MILLIONS OF VINTAGE IMAGES

Arcadia Publishing, the leading local history publisher in the United States, is committed to making history accessible and meaningful through publishing books that celebrate and preserve the heritage of America's people and places.

Find more books like this at
www.arcadiapublishing.com

Search for your hometown history, your old stomping grounds, and even your favorite sports team.

Consistent with our mission to preserve history on a local level, this book was printed in South Carolina on American-made paper and manufactured entirely in the United States. Products carrying the accredited Forest Stewardship Council (FSC) label are printed on 100 percent FSC-certified paper.

MADE IN THE USA